THE LOVE OF

Baseball

Publications International, Ltd.

To Barrett
From Gramma &
Granda N
Christmas '25

Contributing writers: Paul Adomites, Robert Cassidy, Bruce Herman, Dan Schlossberg, Marty Strasen, and Saul Wisnia.

Picture credits: Front cover: Shutterstock.com

AP/Wide World Photos, Chicago Historical Society, Getty Images, Index Stock Imagery, Inc., National Baseball Library & Archive, Peter Ardito, Photofest, Picturequest, PIL Collection, Shutterstock.com, Transcendental Graphics

Factual verification by Bruce Herman and Marty Strasen.

Pages 29 and 93:
Reprinted with permission from *Baseball Digest.*

All Yogi Berra quotes contained in this text are reprinted with permission from LTD Enterprises, Inc., Little Falls, NJ.

Let's get social!

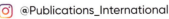 @Publications_International

 @PublicationsInternational

www.pilbooks.com

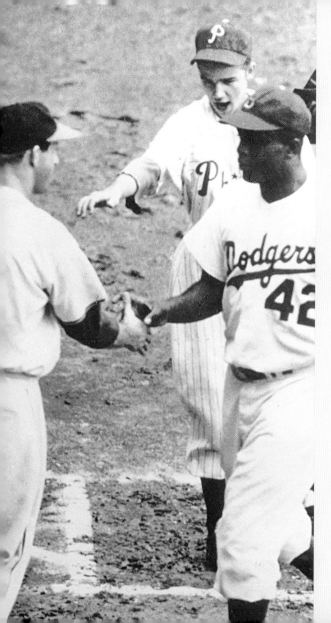

"The way I figured it,
I was even with
baseball and baseball
was even with me.
The game had done
much for me, and I
had done much for it."
—Jackie Robinson

CRACK OF THE BAT

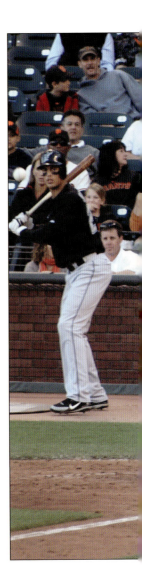

"The crack of the bat, the sound of baseballs thumping into gloves, the infield chatter are like birdsong to the baseball starved."

—W.P. Kinsella

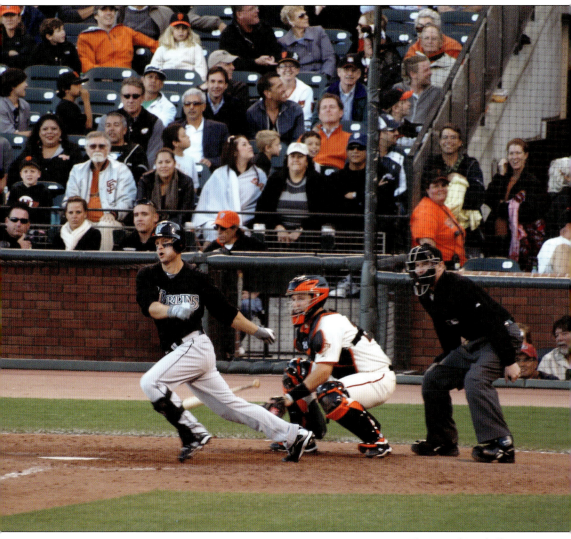

THE GLORIFIED GAME

With the notable exceptions of war and romance, baseball seems to have been glorified in film, television, books, and song more than any other American pastime. The highs and lows of life as defined in a single at-bat moved masses in the celebrated Ernest Lawrence Thayer poem "Casey at the Bat." While the line "there is no joy in Mudville" has become a familiar way of describing failure, hordes of fans have seen fit to rewrite the ending so the hero doesn't strike out. The song "Take Me Out to the Ballgame" has been subject to more renditions and revisions than anything this side of "Happy Birthday," while millions of folks who don't know one double-play combo from another know the

rhythmic flow of the words "Tinker to Evers to Chance."

When musicians Simon and Garfunkel sought to capture the lost innocence of Vietnam-era Americans, all it took was one line in their 1967 hit "Mrs. Robinson": "Where have you gone, Joe DiMaggio? Our nation turns its lonely eyes to you." Beginning with Thomas Edison's 1898 glimpse of two amateur clubs battling it out in "The Ball Game," baseball has been the subject of hundreds of screen adaptations. If not always great art, the results are at least resoundingly American—leaving fans to hope that fathers and sons will play catch, just like Kevin Costner and his dad in *Field of Dreams*.

CROWN FIT FOR A TIGER

Winning a batting Triple Crown is one of the hardest things to do in baseball. In fact, after Boston's Carl Yastrzemski led the AL in batting, home runs, and RBI in 1967, it would be 45 years before someone matched the feat. That someone was Detroit's Miguel Cabrera, who in 2012 led the AL with a .330 average, 44 homers, and 139 RBI.

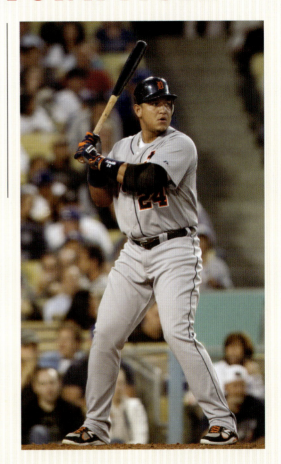

"All I want out of life is that when I walk down the street, people will say, 'There goes the greatest hitter who ever lived.'"

—Ted Williams

NO "E" IN YOUKILIS

From 2006–2008, Boston Red Sox first baseman Kevin Youkilis handled 2,002 consecutive fielding chances without making an error. That record streak spanned 238 games. And when it ended, "Youk" made light of it. "I might not be able to go to sleep tonight," he deadpanned.

FENWAY PARK, BOSTON

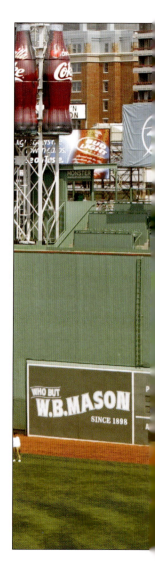

In no place on Earth is the purity of the game and the fan's honest experience of it so powerful as in Boston's Fenway Park. Dating back more than 100 years, the legendary park hosted the 1912 World Series, Babe Ruth's first big-league game, and the immortal feats of Ted Williams. Boston's deeply knowledgeable fans, between bites of a Fenway Frank, will tell you all about it. The famed "Green Monster," which Carlton Fisk slayed in the 1975 World Series, stands like a national monument in left field.

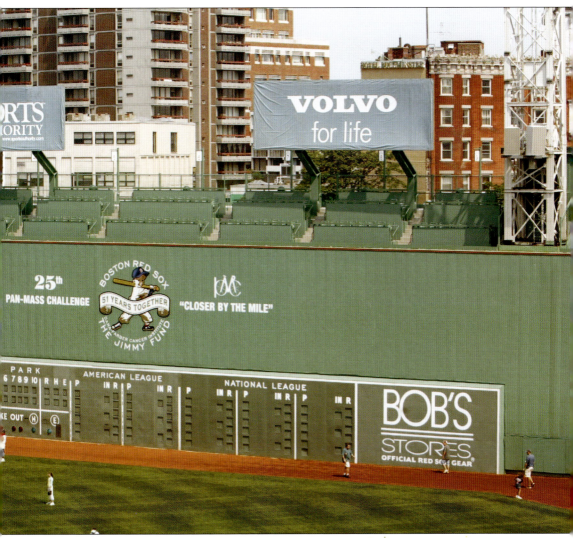

MEMORABLE MOMENT

With the 1956 World Series tied at two games apiece, the Yankees needed some 1–2–3 innings from Don Larsen in the pivotal Game 5 against Brooklyn. He responded with nine of them, throwing the only perfect game—and, in fact, the only no-hitter—in postseason history. After Larsen struck out Dale Mitchell to end the game, catcher Yogi Berra leapt into his pitcher's arms in jubilation. Afterward, a reporter asked, "Is that the best game you ever pitched?"

"Just before I threw the last pitch to Mitchell,
I said to myself, 'Well, here goes nothing.'"

—Don Larsen

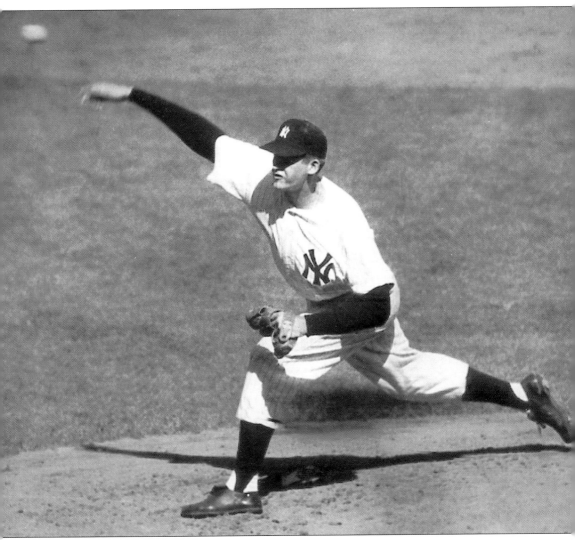

BREAK OUT THE TAPE

Today, home run distances are routinely used in game reports, relayed by announcers, and even displayed on stadium scoreboards. ESPN has a Home Run Tracker that accounts for speed and trajectory and determines how far from home plate a homer would have landed had it not been obstructed by objects like stands, scoreboards, or fans.

Of course, that was not always the case. Back when Babe Ruth, Hank Greenberg, and Jimmie Foxx were blasting baseballs out of parks, there was no attempt to accurately measure the length of home runs. Not until April 17, 1953, were the words "tape-measure shot" ever uttered in reference to a homer.

That afternoon, in Washington's Griffith Stadium, 20-year-old Yankee center fielder Mickey Mantle added the expression to baseball's vernacular with one swing of his bat. Facing Senators lefty Chuck Stobbs, the switch-hitting Mantle took position on the right side of the plate and dug in. Not offering at the first pitch, he met the second dead-on with a tremendous cut that launched the ball on a fast climb to left-center field. It cleared the bleachers, nicked off the upper side of a beer sign atop an old football scoreboard (approximately 460 feet from home plate), then disappeared from view.

The small crowd in the stadium was stunned, but one man acted fast. Running out of the press box into the streets behind left field, Yankee PR director Arthur "Red" Patterson saw a 10-year-old boy with the ball and asked where he found it. Escorted to a yard on an adjacent street, Patterson paced off 105 feet from the base of the wall behind the bleachers. The final estimated distance of 565 feet was reported in the papers the next day—and the tape-measure homer was born.

"I honestly feel that it would be best for the country to keep baseball going...if 300 teams use 5,000 or 6,000 players, these players are a definite asset to at least 20,000,000 of their fellow citizens— and that in my judgment is thoroughly worthwhile."

—President Franklin Delano Roosevelt's "green light" letter to Judge Kenesaw Mountain Landis, January 15, 1942

BABE RUTH

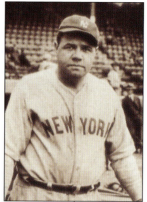

He hit the ball farther than anyone ever had. By late 1919, everyone connected with the baseball world knew who he was. But it wasn't until he moved to New York City that George Herman "Babe" Ruth grabbed the game by the scruff of the neck and shook it silly.

A kid of the streets who learned to play ball while he was an "inmate" at St. Mary's Industrial School for Boys, 19-year-old George made the majors as a pitcher with the Boston Red Sox in 1914. Beginning the next year, he went 78–40 with an ERA under 2.30, helping the club to three World Series titles over four seasons. The left-hander completed a Series-record 29⅔ consecutive scoreless innings in 1918, yet he was so successful a hitter that manager Ed Barrow began giving him outfield assignments on nonpitching days. The 6'2" giant liked the arrangement, and when he was allowed to roam the outfield almost exclusively in 1919, he blasted a major-league-record 29 home runs.

Harry Frazee, Red Sox owner, knew he had a prize. Unfortunately, he had something else as well: a lot of debt. He hadn't yet hit his stride as a super impresario. So when the Yankees asked if Ruth were for sale, Frazee sold him to the New York Yankees in January 1920 for a record sum of $125,000—plus a $300,000 loan. Babe put his stamp of approval on the stupidest move in baseball history with a record-shattering 54 homers that year—more homers than 14 of 16

major-league teams combined—and the fun was on. Fans wanted excitement after the hard realities of World War I and the Black Sox scandal, and Ruth supplied it by showing that one swing could accomplish what had previously taken a series of bunts, steals, and slides.

Ruth was the quintessential hero of the Roaring '20s, a ham for the cameras who could back up his bravado. Dominating baseball as no player has before or since, he averaged 47 home runs and 133 RBI during the decade when just four other players hit as many as 40 homers even once. Over his career, Ruth would lead the Yankees to seven pennants and four world championships (belting 15 homers in World Series play), despite regular indulgences in women, booze, and food. He drew screams and suspensions from his managers and screams of delight from kids—to whom he always seemed to appeal and relate best.

Ruth's records are nothing short of remarkable. His 94–46 pitching mark is often overlooked alongside his .690 slugging average and .474 on-base percentage over his career—records never before approached. When the .342 lifetime hitter retired, his 714 home runs were about twice as many as his nearest competitor. That career total and Babe's season high of 60 homers have since been topped, but his impact on the game remains undisputed. He was baseball's most beloved performer—and its finest.

MAJOR LEAGUE TOTALS									
BA	G	AB	R	H	2B	3B	HR	RBI	SB
.342	2,503	8,399	2,174	2,873	506	136	714	2,211	123

"To be able to even put my name with those legends in baseball before me is pretty special. I could have never thought in my entire life that I could do that. ...
I've done some crazy things in this game and passed some unbelievable names."

—**Albert Pujols,** after he passed Mark McGwire in 2016 to move into the top 10 in career home runs.

"This should prove the leather is mightier than the wood."
—White Sox manager **Fielder Allison Jones** after his 1906 "Hitless Wonders" won the World Series with a .230 club batting average

"Sure as God made green apples, someday, the Chicago Cubs are going to be in the World Series."

—Harry Caray, signing off after the final game of the 1991 season. Someday arrived for the Cubs in 2016, and fans placed green apples next to the late Caray's Wrigley Field statue.

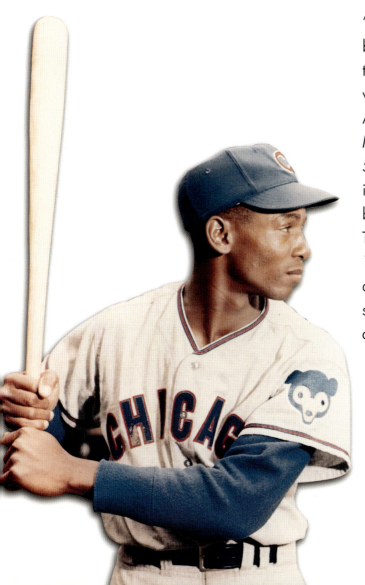

"It's a great day for baseball. Let's play two!" Ernie Banks was fond of saying. Affectionately known as Mr. Cub, Banks belted 512 career home runs, including 290 at his beloved Wrigley Field. Though Banks retired in 1971 and died in 2015 at age 83, his jersey is still worn by the masses at his favorite ballpark.

TED WILLIAMS

He struck out in his first major-league at-bat, homered in his last, and during the 21 years between made the art of hitting his personal quest. Ted Williams looked at the goal of wood meeting ball in a scientific way, and if grades were awarded instead of statistics, his achievements—a .344 lifetime average, 521 homers, and a slugging average (.634) second only to Babe Ruth's—would rank him at the head of his class.

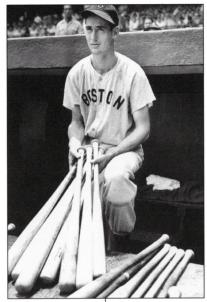

The lessons started early: swings taken before, after, and sometimes during school as a pencil-thin teen in San Diego. He and Pacific Coast League teammate Bobby Doerr both signed on with the Red Sox in 1937, and although Williams didn't make the big club the following spring, his parting shot to Boston's starting outfielders who had ridiculed him—"I'll be back and make more money than the three of you combined"—would prove dead-on. A year later he did return, this time for good.

Rookie Williams distinguished himself in 1939 with a .327 average, 31 homers, and an American League–best and rookie-record 145 RBI. In 1941, Joe DiMaggio captured the attention of the nation with a 56-game hitting streak, but Ted outhit him .412 to

.408 over the course of the streak and finished the season with 37 homers, 120 RBI, and a .406 batting mark—making him the last major-leaguer to reach the charmed .400 level. However, sportswriters awarded the MVP Award to DiMaggio in what turned out to be the first of many times the outspoken Williams (a two-time MVP winner) would be snubbed due to friction with the press.

Williams was a decent left fielder, but when he said he lived for his next at-bat it was no exaggeration. His goal was perfection at the plate; he sought the same from pitchers, and his careful eye enabled him to lead the American League in walks seven times in his first nine full seasons (each time with more than 125). He was criticized for not swinging enough and not hitting in the clutch—this despite an incredible .483 on-base percentage (the best in history) and a .359 lifetime average in September (his best month).

Winner of Triple Crowns in 1942 and '47, Ted led the American League nine times in slugging, six times in batting, six times in runs scored, and four times in homers and RBI. The Player of the Decade for the 1950s hit .388 with 38 homers at age 38 in 1957, won his final batting title (.328) a year later, and slugged 29 long ones in just 310 at-bats in his swan-song season of '60. Despite missing nearly five full seasons as a Navy and Marine flyer and parts of two more to injury, he retired as third on the all-time homer list—and first in many never-ending debates over the greatest hitter of all time.

MAJOR LEAGUE TOTALS									
BA	G	AB	R	H	2B	3B	HR	RBI	SB
.344	2,292	7,706	1,798	2,654	525	71	521	1,839	24

MEMORABLE MOMENT

After winning American League batting titles in 1939 and '40, Yankees great Joe DiMaggio took hitting to a different level in '41. From May 15 through July 16, Joltin' Joe hit safely in 56 consecutive games (batting .408 over the stretch), shattering Willie Keeler's major-league record of 44 games. His streak came to an end due to two great plays by Cleveland third baseman Ken Keltner. DiMaggio shrugged it off and the next day began another streak—this one continuing for 17 games.

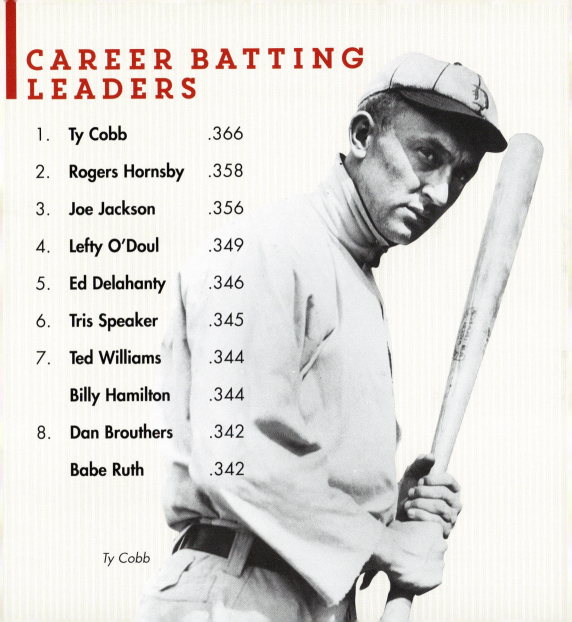

CAREER BATTING LEADERS

1.	**Ty Cobb**	.366
2.	**Rogers Hornsby**	.358
3.	**Joe Jackson**	.356
4.	**Lefty O'Doul**	.349
5.	**Ed Delahanty**	.346
6.	**Tris Speaker**	.345
7.	**Ted Williams**	.344
	Billy Hamilton	.344
8.	**Dan Brouthers**	.342
	Babe Ruth	.342

Ty Cobb

SANDY KOUFAX

Over the last five years of his career (1962–1966), Koufax was as dominating as any pitcher ever had been or would be. He decimated National League hitters, going 111–34 and leading the league in ERA each season.

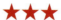

During this five-year run, Sandy won three Cy Young Awards, three pitching "triple crowns," and an MVP Award (1963).

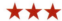

He led Los Angeles to world titles in 1963 (with a 25–5 record, an ERA of 1.88, and 306 strikeouts) and 1965 (26 wins, 2.04 ERA, and 382 Ks). In seven World Series lifetime starts, he went 4–3 with a 0.95 ERA.

Throughout his short career he fired four no-hitters, including a perfect game in 1965.

The youngest player ever inducted into the Hall of Fame, Koufax was forced to retire at age 30 due to the crippling pain of an arthritic elbow.

MAJOR LEAGUE TOTALS									
W	L	ERA	G	CG	IP	H	ER	BB	SO
165	87	2.76	397	137	2,324	1,754	713	817	2,396

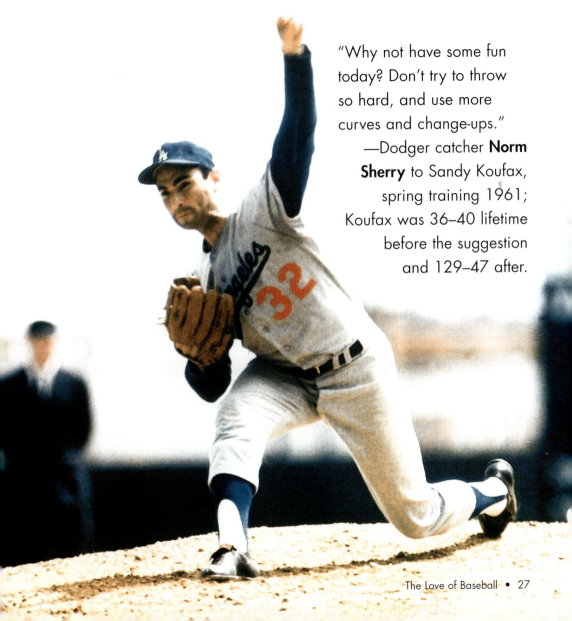

"Why not have some fun today? Don't try to throw so hard, and use more curves and change-ups."
—Dodger catcher **Norm Sherry** to Sandy Koufax, spring training 1961; Koufax was 36–40 lifetime before the suggestion and 129–47 after.

Josh Gibson has been credited with almost 800 home runs, many of them blasted unbelievable distances, over the course of his 17-year career in the Negro Leagues. Many think he might have challenged Babe Ruth's single-season home run record, but he never got the chance. He died of a brain hemorrhage in 1947, just three months before Jackie Robinson broke the color line.

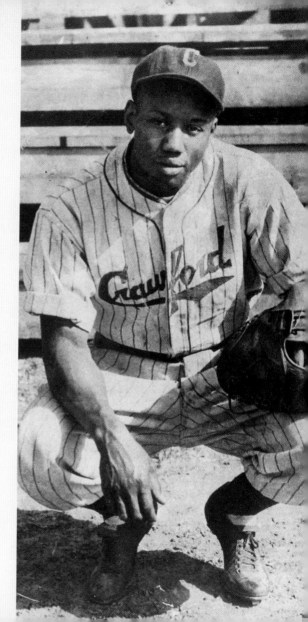

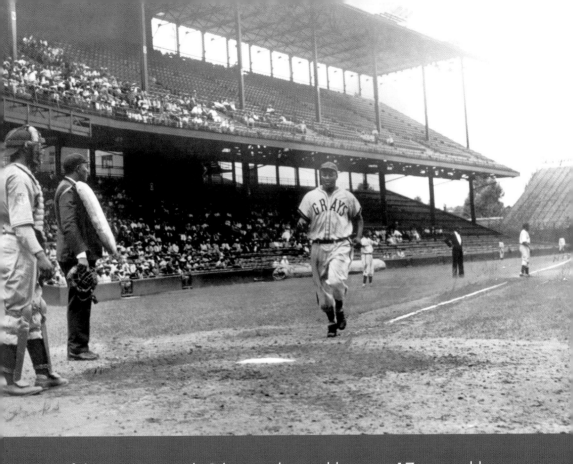

"If they came to Josh Gibson today and he were 17 years old,
they would have a blank spot on the contract and they'd say,
'Fill the amount in.' That's how good Josh Gibson was."
—**Junior Gilliam,** *Baseball Digest,* June 1969

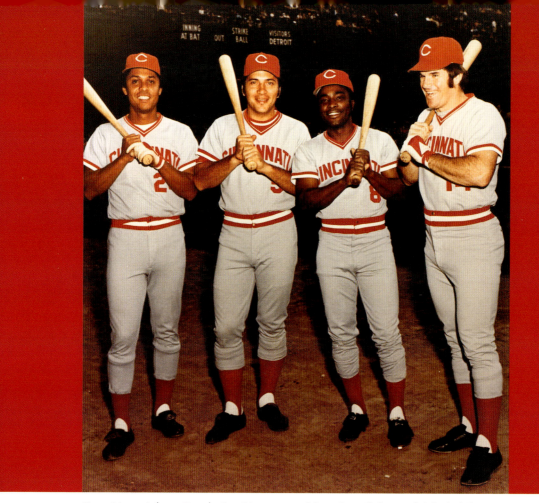

Tony Pérez, Johnny Bench, Joe Morgan, and Pete Rose (left to right) fueled the Big Red Machine, baseball's dominant team of the 1970s. From 1970 to '79, Cincinnati won nearly 60 percent of its games, captured six division titles (plus three second-place finishes), and took a pair of world titles.

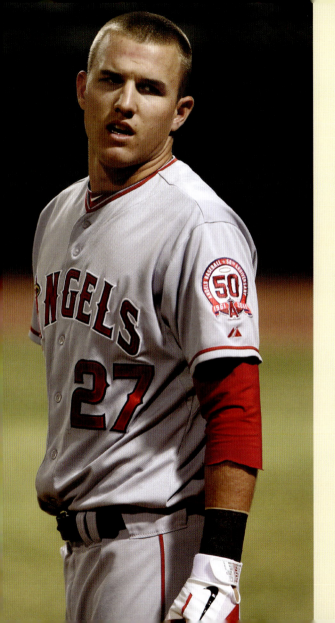

When Mike Trout smashed two homers to lead the Angels to a 6–3 win over the Astros on April 17, 2015, he overtook Alex Rodriguez as the youngest man in Major League history to reach 100 home runs and 100 stolen bases. Trout entered the game with 104 steals and hit his 100th homer at the age of 23 years, 253 days.

THE GAME'S CLASSIEST PLAYERS

★ ★ ★ ★

CLASSIEST PLAYERS

Ernie Banks

Roberto Clemente

Joe DiMaggio

Walter Johnson

Al Kaline

Stan Musial

Jim O'Rourke

Cal Ripken, Jr.

Brooks Robinson

Jackie Robinson

Puerto Rico's Roberto Clemente came to a racially backward town in 1955 and barely spoke the language. The Pittsburgh press ridiculed his poor English and called him a hypochondriac and a malingerer. But fans weren't swayed; they could see his pride and class. One of the greatest humanitarians in the game's history, Clemente lost his life trying to provide aid to Nicaraguan earthquake victims. An elegant statue commemorating him now stands proudly in Pittsburgh.

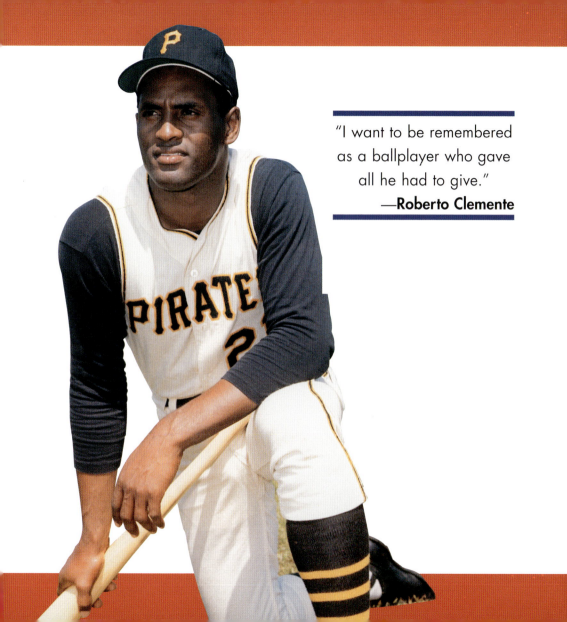

"I want to be remembered as a ballplayer who gave all he had to give."
—**Roberto Clemente**

CY YOUNG

At one point, Babe Ruth's 714 career homers was the baseball record most people predicted would never be broken. Once Henry Aaron topped it, Lou Gehrig's streak of 2,130 consecutive games became the popular choice. Since Cal Ripken put that thought to rest, the question arises anew: Five hundred and eleven wins? Twenty-five a year for more than 20 years? Don't worry, Mr. Young, your mark appears safe.

Walter Johnson, Lefty Grove, and others each have been lauded as the greatest pitcher of all time, but Denton True Young's 511 victories remain the benchmark for all hurlers—and far ahead of runner-up Johnson's 417. Pitching in an era when arms often burned out after a handful of 350-inning seasons,

Young exceeded that total 11 times over a 14-year span and was a 20-game winner on a record 15 occasions. His 7,354 innings are more than 1,300 ahead of runner-up Pud Galvin, and even his record 316 losses look secure for the moment.

Growing up just after the Civil War in Gilmore, Ohio, Young picked up his nickname (shortened from "Cyclone") from a minor-league catcher who was impressed by his speed. The hardy, 6'2" farmhand with the strong legs gained from chasing squirrels reached the majors with the National League Cleveland Spiders in 1890. After a 9–7 debut, he won 20 or more games each of the next nine seasons. Those early years were spent hurling from a pitcher's "box" some 50 feet from home plate. When

the distance was increased to 60'6" with a mound added in 1893, the right-hander didn't seem to miss a beat.

The hard-throwing Young led the NL only twice in wins, and he routinely gave up more hits than innings pitched (although that was the norm in the 1890s). Far from dominating in many of his first 11 seasons, his records grew instead through consistency and durability. His best NL years came in 1892 (36–12 with a league-leading nine shutouts and a 1.93 ERA) and '95 (35–10), but it was after joining the Boston Pilgrims of the new American League in 1901 that Young had his most dominating campaigns. Leading the AL in victories in his first three years with Boston (going 33–10, 32–11, and 28–9), he posted a 1.95 ERA over the span—topping it off in 1903 with two wins as Boston beat Pittsburgh in the first modern World Series.

> "Son, I won more games than you'll ever see."
> —**Cy Young,** responding to a youthful reporter

Author of three no-hitters (including a 1904 perfect game), Young went 21–11 with a 1.26 ERA at age 41. After his career ended in 1911, he lived for 44 more years, attending old-timer's functions and tossing out the first ball at the 1953 World Series. Others may have been flashier, but when the two major leagues honor their best pitchers each season, they do so with a plaque named for the game's winningest hurler—Cy Young.

MAJOR LEAGUE TOTALS									
W	L	ERA	G	CG	IP	H	ER	BB	SO
511	316	2.63	906	750	7,356.0	7,092	2,147	1,217	2,798

MEMORABLE MOMENT

After World War II, Brooklyn Dodgers general manager Branch Rickey felt it was time to field the majors' first African-American player—but it had to be someone who was mentally tough. Jackie Robinson was the man. Premiering with the Dodgers on Opening Day in 1947, the speedy second baseman endured racist taunts and vicious tags, yet never retaliated. His courage, class, and dynamic play earned him the NL Rookie of the Year Award. In 1997 Robinson's No. 42 was retired by Major League Baseball.

On April 14, 2017, the Chicago White Sox made history by starting Avisaíl Garcia, Willy Garcia, and Leury Garcia—no relation—in the outfield. In the 1960s, Brothers Felipe, Matty, and Jesús Alou played together in the New York Giants outfield but were never all in the same starting lineup.

1912: Red Sox vs. Giants

The World Series was only just beginning to take hold of the psyche of America in 1912—but this classic closed the deal. Two powerhouse teams, led by ace pitchers Christy Mathewson (New York Giants) and Smokey Joe Wood (Boston Red Sox), banged heads for eight games. It couldn't have been wilder. "There never was another like it," said the *Spalding Guide*.

The Series was full of clutch plays and intrigue, spectacular pitching and snappy hitting. Wood won the first game 4–3 after fanning the last two batters with runners on second and third.

Game 2 ended in a 6–6 tie after 11 innings because of darkness. The final game featured great catches and excruciating bobbles. Boston, capitalizing on Fred Snodgrass's dropped fly ball in the 10th inning, took Game 8.

> "I threw so hard, I thought my arm would fly right off my body."
> —**Smokey Joe Wood** on the ninth inning of Game 1 of the 1912 World Series

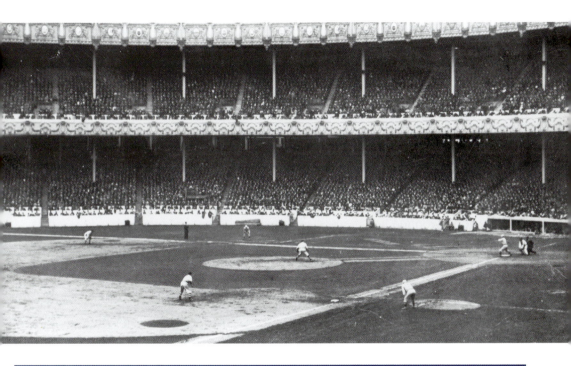

Game 1	Boston 4 at New York 3		**Game 5**	New York 1 at Boston 2
Game 2	New York 6 at Boston 6 (11)		**Game 6**	Boston 2 at New York 5
Game 3	New York 2 at Boston 1		**Game 7**	New York 11 at Boston 4
Game 4	Boston 3 at New York 1		**Game 8**	New York 2 at Boston 3 (10)

PITCH CLOCK
SPEEDS UP GAME

Take a great game, condense it into a shorter time frame, and watch the excitement level soar. That's what Major League Baseball had hoped for when it instituted a pitch clock to speed up play in 2023, and that's what the results seem to show.

A clock now mandates that pitchers have 30 seconds to resume play between batters. Between pitches, they have 15 seconds if the bases are empty and 18 if there are runners—down from 20 in the first year of the rule. Batters must be in the box and alert with eight seconds on the clock. Violations call for a strike on the batter, who gets one time-out per at-bat, and a ball on the pitcher.

The average game time in 2021 was three hours, 10 minutes. Thanks to the pitch clock, that was cut to two hours, 36 minutes in 2024—the lowest in 40 years. Perhaps not coincidentally, TV ratings and attendance also experienced a jump.

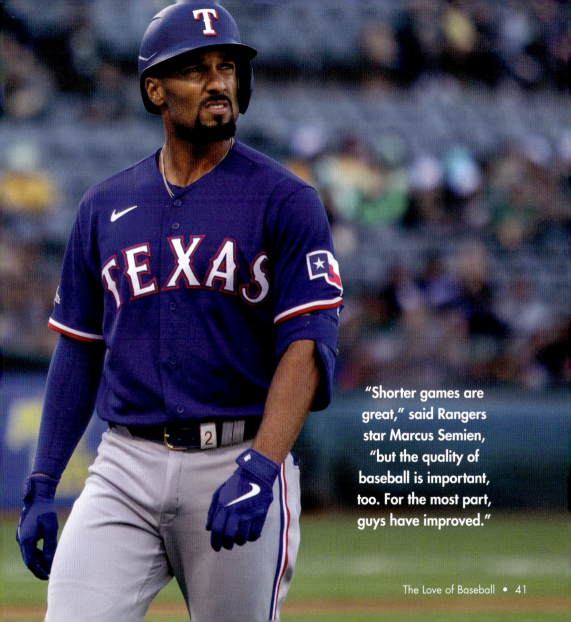

"Shorter games are great," said Rangers star Marcus Semien, "but the quality of baseball is important, too. For the most part, guys have improved."

BRAVES MAKE A GOOD THING BETTER

From its April 2017 Opening Day, Truist Park—then SunTrust Park—could make a claim to being one of baseball's must-see stadiums. Its use of brick and old-school design gave it a certain timelessness, as if fans were stepping into a classic ballpark. Yet once inside, its sparkling amenities, pinpoint sightlines, and use of modern technology screamed state-of-the-art.

One of the great draws of a trip to Truist Park is The Battery Atlanta, an entertainment district that sprung to life around the park. It was absolutely by design that a series of shops, restaurants, nightlife, work venues, and living quarters welled up in this area 10 miles northwest of downtown Atlanta.

Neither the park nor the neighborhood is resting on its laurels. The Bullpen, a private lounge beneath the seats, opened in 2025 to give fans an upgraded viewing experience. The Braves also expanded the popular Chop House seating area. "The upgrades are all about making Truist Park the top place to watch baseball," Braves President and CEO Derek Schiller said.

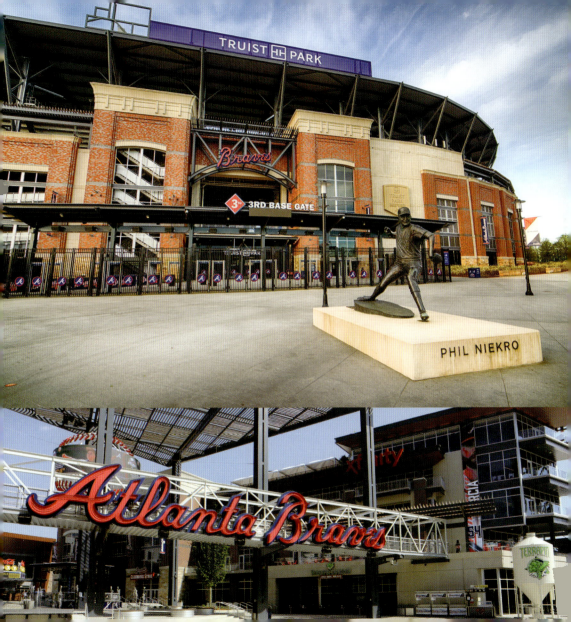

JIMMIE FOXX

In his heyday, ol' Double X was called "the right-handed Ruth." He belted more homers in the 1930s (415) than anyone else, and when he retired in 1945, his 534 home runs were the second most in history, trailing only Babe Ruth's 714.

He won his first MVP Award with the Philadelphia A's in 1932 and followed it up with a Triple Crown/MVP year in '33 (.356–48–163). He took home a third MVP trophy with the Boston Red Sox in '38.

With a .325 lifetime average, 534 homers, 1,922 RBI, and .609 slugging percentage, Foxx was a first-ballot Hall of Famer.

| MAJOR LEAGUE TOTALS | | | | | | | | | |
BA	G	AB	R	H	2B	3B	HR	RBI	SB
.325	2,317	8,134	1,751	2,646	458	125	534	1,922	88

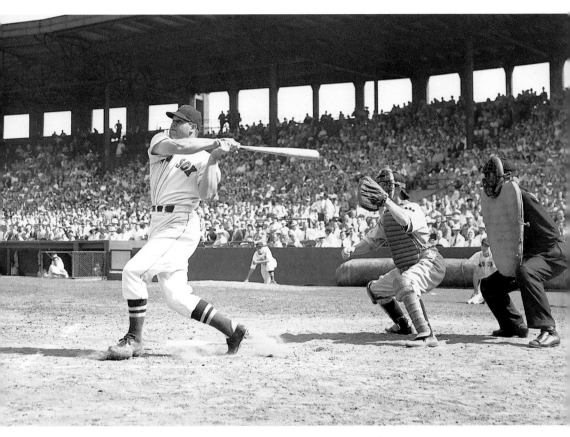

"Next to Joe DiMaggio, Foxx was the greatest player I ever saw.
When Foxx hit a ball, it sounded like gunfire."

—Ted Williams

THE NEGRO LEAGUES

Until Jackie Robinson broke the color barrier in 1947, African Americans were banned from Major League Baseball. Some of the best pitchers and sluggers of all time lived out their dreams in the Negro Leagues, which began in 1920 and thrived from 1935 to 1948.

Life in the Negro Leagues was a hardscrabble existence. The players were denied accommodations at many hotels and restaurants, which still catered exclusively to white customers. They stayed at black boarding houses or in the homes of people within the African-American community. In the worst scenario, they would pitch a tent in the outfield and sleep there until the game the next day. Sometimes they would fish for their dinner in nearby lakes and rivers.

But to many of the men who donned Negro League uniforms, the opportunity to play professional baseball was worth enduring such conditions. "It was thrilling to me," said James Moore, who played first base for the Atlanta Black Crackers, Baltimore Elite Giants, and Newark Eagles. "We'd travel from city to city....I was playing baseball and I just loved it."

Negro League teams often played each other in major-league parks. On other occasions, the teams played against American Legion clubs, local police departments, or semipro teams. Players looked forward to exhibition games against major-leaguers, including such stars as Lefty Grove, Jimmie Foxx, and Joe DiMaggio.

"When I first began to play, I thought we were inferior to the white ballplayer," said Moore. "[But] I played against a lot of major-league ballplayers. We beat them some and they beat us some. I realized they were human and we were human. It really made me feel good

to be hitting the ball against guys who were in the major leagues."

Many Negro Leaguers have earned enshrinement in the National Baseball Hall of Fame in Cooperstown. Catcher Josh Gibson, said to be the greatest Negro League hitter of all, belted an estimated 800 home runs in league and exhibition games, including a 580-foot moon shot at Yankee Stadium, and ripped .426 in contests against major-leaguers.

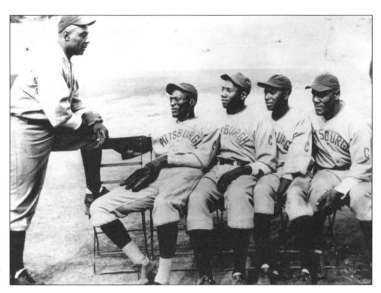

Pittsburgh Crawfords Oscar Charleston, Rap Dixon, Josh Gibson, Judy Johnson, and Jud Wilson (left to right)

After Robinson debuted with the Brooklyn Dodgers in 1947, other Negro League stars jumped to the majors, from Satchel Paige and Ernie Banks to Willie Mays and Hank Aaron. The last of the Negro Leagues, the Negro American League, disbanded in 1957, thus ending a rich and vibrant era of professional baseball.

HOME RUN DERBY

Major League baseball has tinkered with the Home Run Derby rules through the years, going from "outs" to a time limit and experimenting with bonus swings. The spectacle of watching a Major Leaguer crack ball after ball deep into the night sky, however, remains a constant.

In 2023, Julio Rodríguez didn't win the Home Run Derby, but he won the hearts of his home-stadium Seattle fans with a record-breaking first round. With fans chanting his name, the Mariners slugger set a single-round record with 41 taters—for a cumulative 16,556 feet of home run distance.

Derby Winners

2024 Teoscar Hernández

2023 Vladimir Guerrero Jr.

2022 Juan Soto

2021 Pete Alonso

2019 Pete Alonso

2018 Bryce Harper

2017 Aaron Judge

2016 Giancarlo Stanton

2015 Todd Frazier

2014 Yoenis Céspedes

2013 Yoenis Céspedes

2012 Prince Fielder

2011 Robinson Canó

2010 David Ortiz

2009 Prince Fielder		**1993** Juan González	
2008 Justin Morneau		**1992** Mark McGwire	
2007 Vladimir Guerrero		**1991** Cal Ripken Jr.	
2006 Ryan Howard		**1990** Ryne Sandberg	
2005 Bobby Abreu		**1989** Eric Davis	
2004 Miguel Tejada		Rubén Sierra	
2003 Garret Anderson		**1987** Andre Dawson	
2002 Jason Giambi		**1986** Darryl Strawberry	
2001 Luis Gonzalez		Wally Joyner	
2000 Sammy Sosa		**1985** Dave Parker	

2009 Prince Fielder

2008 Justin Morneau

2007 Vladimir Guerrero

2006 Ryan Howard

2005 Bobby Abreu

2004 Miguel Tejada

2003 Garret Anderson

2002 Jason Giambi

2001 Luis Gonzalez

2000 Sammy Sosa

1999 Ken Griffey Jr.

1998 Ken Griffey Jr.

1997 Tino Martinez

1996 Barry Bonds

1995 Frank Thomas

1994 Ken Griffey Jr.

1993 Juan González

1992 Mark McGwire

1991 Cal Ripken Jr.

1990 Ryne Sandberg

1989 Eric Davis

Rubén Sierra

1987 Andre Dawson

1986 Darryl Strawberry

Wally Joyner

1985 Dave Parker

Most Homers in a Single Derby

91—Vladimir Guerrero Jr., 2019

82—Randy Arozarena, 2023

81—Julio Rodríguez, 2022

TY COBB

When a movie on the life of Ty Cobb premiered in theaters in 1994, it was gone in a matter of weeks—most folks showing little interest in paying tribute to the greatest hitter for average (.366) in major-league history. More than 40 years after his death, the reputation of "The Georgia Peach" apparently hasn't changed much. He might have hit and run better than anyone else in baseball, but this was still one nasty son of a gun.

Cobb used his brutal ferocity to attack the game and beat down opponents. Harassed as a scrawny 18-year-old with the Tigers in 1905, he quickly added weight and muscle along with a philosophy of playing hard and trusting no one. He never hit below .316 after his rookie season, and in 1907, at the age of 20, he won his first batting title with a .350 mark. He also led the league with 116 RBI, 212 hits, and 49 stolen bases.

His skills were thereby established: a dead-ball-era hitter who would never accept the home run as a viable part of the game. He would rather bunt than swing for the fences. In the field, he used his great speed and a solid arm to cut down runners, and he registered 20 or more assists on 10 occasions.

But what he did best was hit. His 1907 batting title was the first of 9

straight and 12 overall (although 2 of the batting titles are disputed). Cobb led the Tigers to three straight pennants, from 1907 to '09, and remained the key to Detroit's attack for 20 years. Perennially among American League leaders in slugging and steals (he won six stolen base crowns), he also was the team's most reliable RBI man for many years—averaging 109 a season from 1907 to '12 en route to 1,937 for his career. As a runner, he felt no shame in sliding with his spikes raised high.

Cobb won the Triple Crown in 1909 with nine homers, 107 RBI, and a .377 average. Two years later he had perhaps his finest season with a career-high .420 average and league-leading totals in hits (248), doubles (47), triples (24), runs (147), RBI (127), and steals (83). In 1915 he set a stolen base record of 96

that held for nearly 50 years, and in 1922 he hit .400 for the third and last time at the age of 35. He served as a player and manager in his final six years with the Tigers, then joined Connie Mack's Athletics in '27 to finish his career. He retired rich from wise investments but virtually devoid of friends. His major-league records for hits (4,189) and steals (892) have since been topped, but his .366 mark will likely endure—along with the sordid reputation of the man who achieved it.

MAJOR LEAGUE TOTALS									
BA	G	AB	R	H	2B	3B	HR	RBI	SB
.366	3,034	11,429	2,245	4,189	724	297	117	1,937	892

ORIOLE PARK AT CAMDEN YARDS, BALTIMORE

Completed in 1992, Camden Yards was the first of the magnificent retro-style ballparks. Part of the urban landscape, the park is buffered by the hundred-year-old B&O Warehouse beyond the right-field fence. Inside, Camden Yards boasts comfortable seats, a dual-level bullpen, an ivy-covered wall, and even fresh flowers along the walkways. Some fans come just for the beverages and food, which include freshly squeezed lemonade and Boog's BBQ.

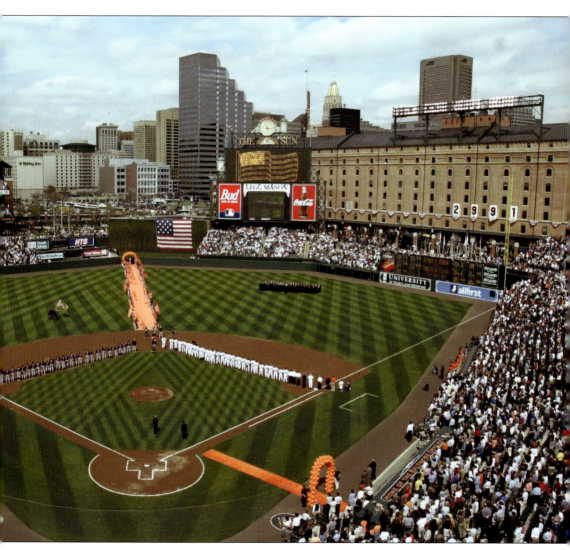

ROGERS HORNSBY

From 1921 to 1925, through 696 games, 2,679 at-bats, and countless doubleheaders in the sweltering St. Louis sun, Hornsby averaged a .402 batting mark—perhaps the greatest hitting stretch ever.

His lifetime .358 batting average is the NL record and is second only to Ty Cobb in major-league history.

Hornsby eclipsed the much-vaunted .400 mark three times, including a 20th-century-record .424 for the St. Louis Cardinals in 1924.

The man known as "Rajah" won six consecutive batting titles from 1920 to '25 and captured the National League Triple Crown in 1922 (.401–42–152) and 1925 (.403–39–143).

MAJOR LEAGUE TOTALS									
BA	G	AB	R	H	2B	3B	HR	RBI	SB
.358	2,259	8,173	1,579	2,930	541	169	301	1,584	135

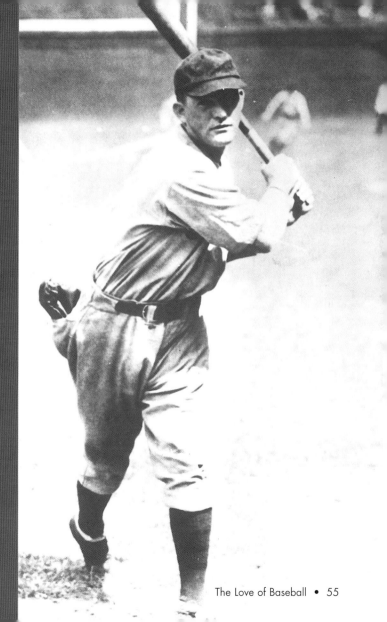

"Any ballplayer that don't sign autographs for little kids ain't an American."
—**Rogers Hornsby**

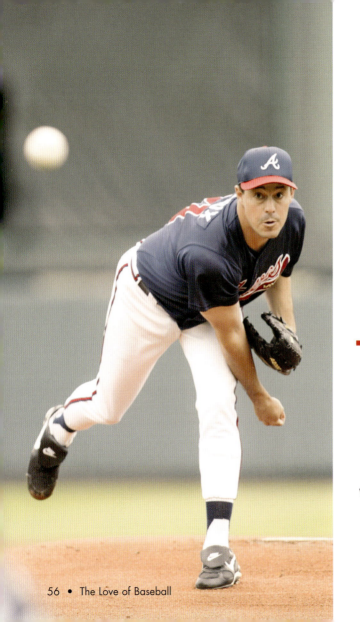

With a record 17 straight 15-win seasons, Greg Maddux was the most consistent pitcher of his era and one of the greatest in history. A cerebral artist who exploited hitters' weaknesses, Maddux went 19–2 with a 1.63 ERA for Atlanta in 1995 and won his 300th game with the Cubs in 2004. He finished his remarkable career with 18 Gold Glove Awards—more than anyone in history—and four Cy Young Awards (consecutively from 1992–1995).

Still beloved in his native Japan, Ichiro Suzuki (known in the baseball world simply as Ichiro) in 2016 became the 30th major leaguer to reach the 3,000-hit mark, and just the second player to do so with a triple. While that honor came as a Miami Marlin, it was with the Seattle Mariners that he took the Majors by storm in a spectacular 2001 American League Rookie of the Year debut. A bat magician, he won the AL MVP award after leading the league in batting (.350), hits (242), and steals (56) in '01. And he set a major-league record for hits in a season with 262 in 2004.

Luis Aparicio set a standard of athleticism for shortstops with his acrobatic defense and baseline-burning speed. "Little Louie" won nine Gold Gloves and the same number of consecutive stolen-base titles.

Lou Brock was among the first players to truly change games—and the game itself—with his speed. Traded by the Cubs to St. Louis in 1964, he stole 43 bases that year to push the Cardinals to the World Series.

YOGI BERRA

Seldom has a person's exterior allowed for more misconceptions about his character or capabilities than in the case of Lawrence Peter Berra. A squat, funny-looking kid from St. Louis, Berra developed a reputation for being uncouth and unworldly and saying things that made

no sense. In reality this man, whose appearance and disposition earned him the nickname "Yogi," was a shrewd and successful businessman, one of the most popular Americans of the 20th century, and the most consistently superb catcher of baseball's Golden Era.

The final statement is no stretch. Roy Campanella, Johnny Bench, and others had periods in which their accomplishments outshone Berra's best seasons, but for year-in and year-out excellence,

Yogi stands alone. In 14 full seasons from 1948 to '61, the 5'8" receiver with the infectious grin averaged 23 homers and 94 RBI, led American League catchers in games caught and total chances eight times each, and from 1957 to '59 went a stretch of 148 games and 950 chances without an error. Not coincidentally, he played on 14 pennant-winners and 10 world-championship clubs in his 19-year career, setting records for World Series games, hits, and doubles along the way.

Berra reached the Yankees late in 1946 after a stint in the Navy. Over the next two years, he split time as a backup catcher and outfielder. As the Yankees' starting catcher in 1948, Yogi rapped .305 with 14 homers and

98 RBI. Thus began a career of sustained brilliance. Starting in 1949, Berra amassed at least 20 home runs and 82 RBI for 10 straight years, reaching heights of 30 homers twice (then an American League record for catchers), 125 RBI (during a string of four straight 100-RBI seasons), and a top batting average of .322 in 1950. A great guess hitter who performed best in the clutch, Berra was named MVP in 1951, '54, and '55, yet was so consistent that his award-winning years were indistinguishable from the rest.

Defensive tutoring from Hall of Famer Bill Dickey made Yogi a sure-handed receiver. His expert handling of pitchers, achieved by focusing on their varying personalities, was part of his own brand of genius.

Berra may have been known for spouting malapropisms and making people scratch their heads and chuckle, but the Hall of Famer usually got his point across—along with a laugh. Yogi was probably the most popular ballplayer of his generation, and his personality translated well to managing. He was just the second manager—after Joe McCarthy—to win pennants in both leagues, doing it with both the Yankees (1964) and Mets ('73). Some may still think him a jokester; in reality, he is a true American success story.

> "He seemed to be doing everything wrong, yet everything came out right. He stopped everything behind the plate and hit everything in front of it."
>
> **—Mel Ott**

MAJOR LEAGUE TOTALS									
BA	G	AB	R	H	2B	3B	HR	RBI	SB
.285	2,120	7,555	1,175	2,150	321	49	358	1,430	30

DEREK JETER

Jeter played every one of his 2,747 games in a New York Yankees uniform.
The next-closest Yankee in history in tenure with the team
is Mickey Mantle with 2,401.

Only five players in Major League history—Pete Rose, Ty Cobb, Hank Aaron,
Stan Musial, and Tris Speaker—have more hits than Jeter's 3,465.

Eleven times in his career, Derek hit .300 or better and finished
with double-figure totals in home runs and stolen bases.
No player in history recorded more such campaigns.

Jeter helped the Yankees win five World Series championships. In 2000,
he was named MVP of both the All-Star Game and the World Series.

Between July 21, 2006 and May 16, 2007,
Derek played in 100 games and got a hit in 92 of them.

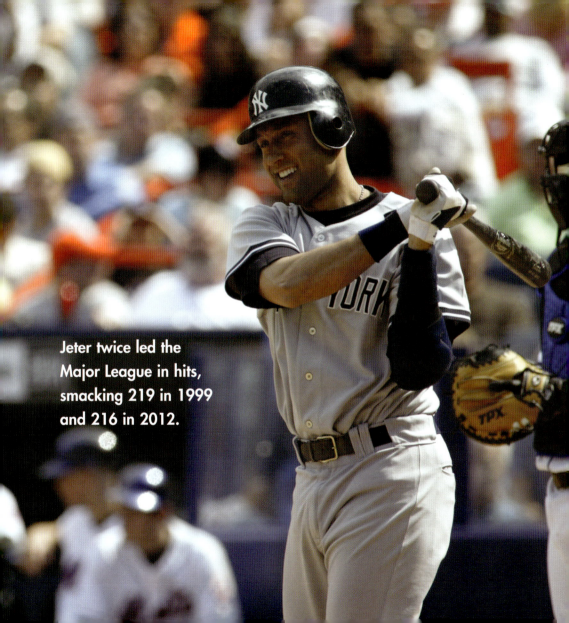

Jeter twice led the
Major League in hits,
smacking 219 in 1999
and 216 in 2012.

BASEBALL'S BEST BUNTERS

★★★★

BEST BUNTERS

Richie Ashburn
Brett Butler
Rod Carew
Ray Chapman
Ty Cobb
Eddie Collins
Kid Gleason
Willie Keeler
Juan Pierre
Phil Rizzuto

Wee Willie Keeler, a turn-of-the-century star, was one of the game's greatest "scientific" hitters, using his smarts to wring every hit he could out of the dead ball. Keeler was a founding father of the "Baltimore chop," swatting the ball directly downward on the hard Oriole infield in order to beat it out for a hit. Quite simply, his bunting was a precision act. The 5'4" Keeler shared his wisdom by advising hitters simply to "hit 'em where they ain't."

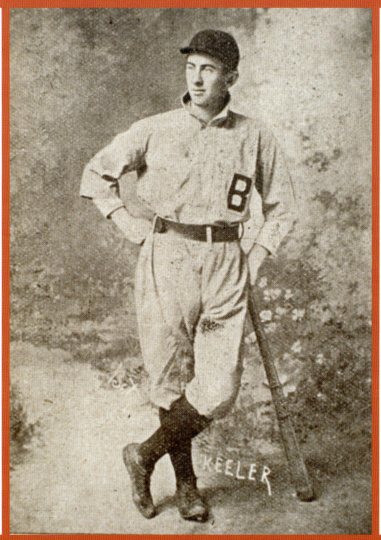

MEMORABLE MOMENT

Sixty-one years after Roger Maris broke Babe Ruth's record with 61 home runs, Aaron Judge bested Maris to become the AL record-holder. Judge's 62nd homer of 2022 opened the second game of a day-night October doubleheader in Texas and made the Yankees slugger the Majors' first 60-home run hitter in more than 20 years.

"It's a historically great season," said New York manager **Aaron Boone** after the game. "One we'll talk about when we're long gone."

NOTABLE NICKNAMES

Luke "Old Aches and Pains" Appling

Steve "Bye-Bye" Balboni

Pee Wee Butts

Will "The Thrill" Clark

Fidgety Phil Collins

Pickles Dillhoefer

Spittin' Bill Doak

Leo "The Lip" Durocher

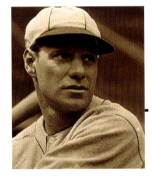

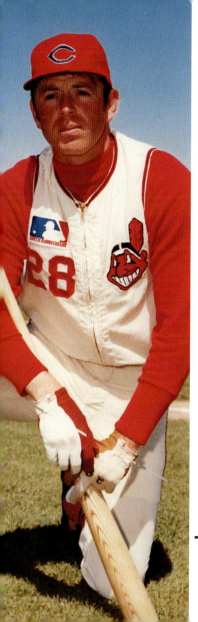

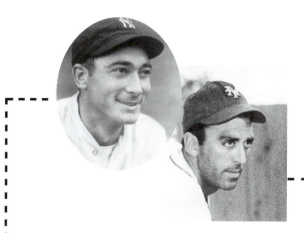

Al "The Mad Hungarian" Hrabosky

Tony "Poosh 'Em Up" Lazzeri

Aurelio "Señor Smoke" López

Sal "The Barber" Maglie

Raw Meat Bill Rodgers

Harry "Suitcase" Simpson

Dick "Dr. Strangeglove" Stuart

1931: Cardinals vs. Athletics

They weren't called the "Gashouse Gang" just yet, but this St. Louis Cardinals team was definitely smoking against the proud and potent Philadelphia Athletics of Connie Mack. This Mack club could have been the finest ever. The A's were making their third consecutive World Series appearance, averaging more than 104 wins each year. Five of their members are now enshrined in the Hall of Fame.

But the pesky Cards didn't care, even though the same A's had whipped them in six games in the '30 Series. The key was the amazing performance of Pepper Martin *(right)* for St. Louis. He undressed the mighty A's with his boisterous batting (12-for-24) and dazzling baserunning (five steals). And with the winning run at the plate for the A's in the ninth inning of Game 7, the man who grabbed the fly ball to end it all was...Pepper Martin.

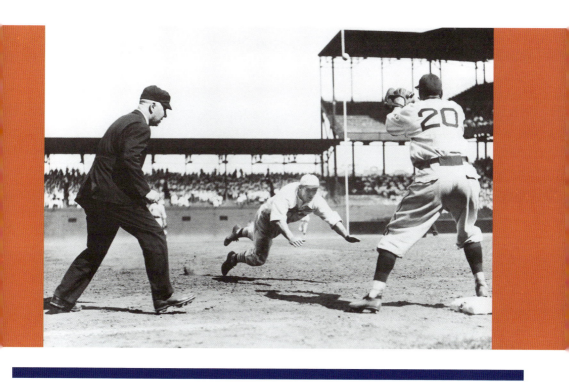

Game 1	Philadelphia 6 at St. Louis 2		**Game 5**	St. Louis 5 at Philadelphia 1
Game 2	Philadelphia 0 at St. Louis 2		**Game 6**	Philadelphia 8 at St. Louis 1
Game 3	St. Louis 5 at Philadelphia 2		**Game 7**	Philadelphia 2 at St. Louis 4
Game 4	St. Louis 0 at Philadelphia 3			

CAREER HIT LEADERS

1. **Pete Rose** 4,256
2. **Ty Cobb** 4,191
3. **Hank Aaron** 3,771
4. **Stan Musial** 3,630
5. **Tris Speaker** 3,514
6. **Derek Jeter** 3,465
7. **Honus Wagner** 3,430
8. **Carl Yastrzemski** 3,419
9. **Albert Pujols** 3,384
10. **Paul Molitor** 3,319

Pete Rose

"I became a good pitcher when I stopped trying to make them miss the ball and started trying to make them hit it."

—Sandy Koufax

CHAMPION OF THE LITTLE GUY

Bill Veeck brought exploding scoreboards, a 42-year-old rookie, and a 3'7" pinch hitter to the major leagues, and while he didn't mix too well with his fellow owners, he certainly gave the fans a good time. Through a wild life spent putting forth gimmicks, stunts, and some very good teams, Veeck offered others the chance to enjoy the game as much as he did while living up to his Hall of Fame epitaph: "Champion of the Little Guy."

Veeck's impact on baseball began early. As a teenager working for the Chicago Cubs club owned by his father, he planted the seeds from which burst forth the ivy that still covers the outfield walls of Wrigley Field. He quit college at age 19 to become full-time treasurer of the Cubs, then was off to minor-league Milwakee—where, with the help of home-plate weddings, fireworks, and pig giveaways, he turned a moribund franchise into a club so popular it prompted Boston Braves owner Lou Perini to move his big-league team to Wisconsin a decade later. Thanks to World War II, Veeck had a wooden leg, but most folks still found it impossible to keep up with the "Maverick" and his shenanigans.

It was more of the same in the majors. Veeck built a World Series champion in Cleveland by 1948. And by dreaming up promotions such as "Good Ol' Joe Early" night—when he showered an average fan with gifts—he demolished Yankee attendance records by drawing more than 2.6 million fans.

One of his wildest moves in '48 was

bringing aboard ancient "rookie" pitcher and Negro League legend Satchel Paige, who went 6–1. A year earlier, when Veeck broke the AL color line by bringing Larry Doby to Cleveland, he received 20,000 letters from incensed fans and answered each by hand. After Cleveland was officially eliminated from the 1949 pennant race, the Maverick led a funeral cortege onto the field and buried the club's '48 championship banner.

A few years later Veeck sold the Tribe and purchased the dismal St. Louis Browns, more than doubling attendance for a seventh-place club thanks to stunts like the 1951 appearance of No. ⅛ Eddie Gaedel—whose 3'7" frame prompted a walk on four pitches. From there it was on to the White Sox, where Veeck copped another pennant in 1959 and set club attendance marks due in part to a scoreboard that shot off fireworks following home runs. The old guard of ownership never appreciated his free spirit, but he always had the love of his players and, most important, the fans. Late in life he often sat in the Wrigley Field bleachers, shirtless, and with his wooden leg serving as a beer coaster and ashtray.

Veeck Contributions:

- Signed first black player in AL
- Hired first black front-office exec
- Produced last Cleveland World Series title
- Turned games into spectacles
- Added pregame radio shows
- Put names on uniforms

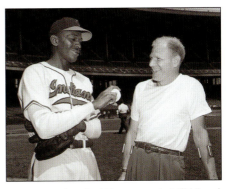

Satchel Paige with Bill Veeck

TRIS SPEAKER

Speaker holds the major-league record for career doubles with 792, including a whopping 59 in 1923.

He ranks among the top six in ML history in career batting, hits, and triples, and he batted in the .380s five times throughout his stellar career, including .383 in his AL MVP season of 1912. Speaker remains the only major-leaguer to rack up three hitting streaks of 20 games or longer in the same season.

Considered the greatest defensive outfielder of his day, "The Gray Eagle" (called that due to his prematurely graying hair) is the Majors' all-time leader in outfield assists (448).

MAJOR LEAGUE TOTALS									
BA	G	AB	R	H	2B	3B	HR	RBI	SB
.344	2,789	10,208	1,881	3,515	792	223	117	1,559	433

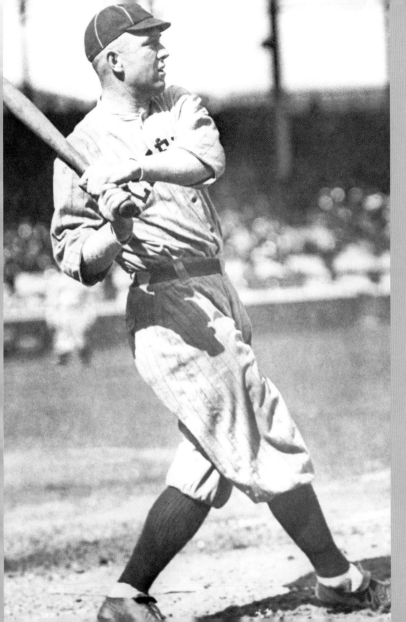

His name has not maintained quite the same luster of Babe Ruth and Ty Cobb, but for many years Tris Speaker was usually the third man mentioned as one of the greatest outfielders of all time.

MEMORABLE MOMENT

After trailing crosstown rival Brooklyn by 13½ games on August 11, 1951, the New York Giants stunningly caught the Dodgers, forcing a three-game playoff. Down 4–2 in the bottom of the ninth in Game 3, New York sent Bobby Thomson to the plate with two men on—and he promptly drilled one over the left-field fence. "The Giants win the pennant!" blared broadcaster Russ Hodges. "And they're going crazy!" Thomson's homer was soon dubbed the "shot heard 'round the world."

"Branca throws...There's a long drive! It's going to be...I do believe!
The Giants win the pennant! The Giants win the pennant!
The Giants win the pennant!"
—Radio broadcaster **Russ Hodges,** October 3, 1951

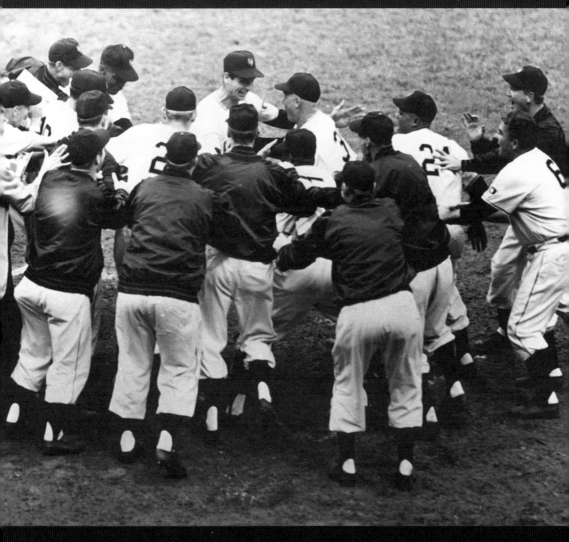

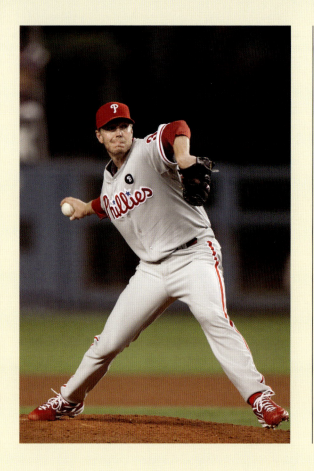

HALLADAY FRENZY

One good no-hitter deserved another for Phillies ace Roy Halladay in 2010. After throwing a perfect game against the Marlins on May 29, the right-hander made his first-ever Major League playoff appearance a memorable one once October came around. Becoming just the second pitcher in history to throw a playoff no-hitter (after Don Larsen's 1956 perfect game), Halladay limited the Reds to one base runner in a 4–0 victory at Citizens Bank Park. "It's a little bit surreal," he said.

BOXCAR BINGO

A glance at the boxscore from Houston's 5–1 loss to Tampa Bay on June 24, 2011, had readers seeing triple. The starting pitcher for the Astros was Wandy Rodríguez. Their middle man was Fernando Rodríguez (no relation). And pitching the ninth inning was Aneury, you guessed it, Rodríguez (no relation).

The Astros did not earn many distinctions that season, losing 106 games, but they did become the first team in Major League history to send three pitchers to the hill with the same last name in one game.

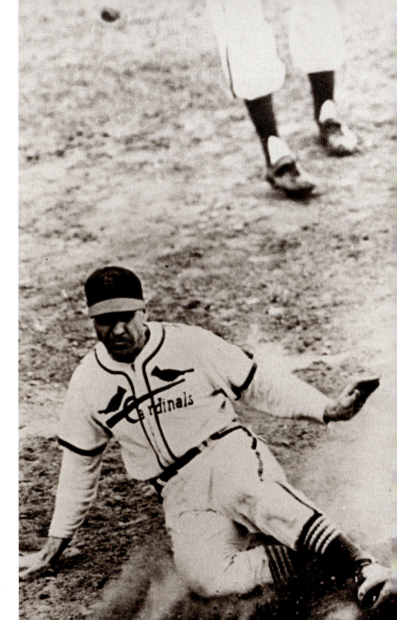

The Cardinals'
Enos Slaughter was
playing with
a broken elbow
when he made his
"mad dash"—
a sprint from first
base to home on
Harry Walker's hit
that decided the
1946 World Series.

CAREER STOLEN BASE LEADERS

1. **Rickey Henderson** 1,406
2. **Lou Brock** 938
3. **Billy Hamilton** 914
4. **Ty Cobb** 897
5. **Tim Raines** 808
6. **Vince Coleman** 752
7. **Arlie Latham** 742
8. **Eddie Collins** 741
9. **Max Carey** 738
10. **Honus Wagner** 723

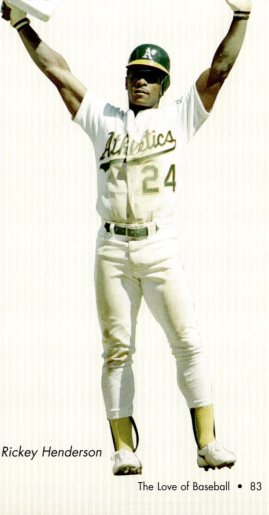

Rickey Henderson

1924 : Senators vs. Giants

This was the season legendary Washington Senators hurler Walter Johnson was supposed to triumph after spending years without winning a pennant. But he lost his first two starts to the New York Giants, and Washington, under rookie manager Bucky Harris, was fighting to hold on. Three of the first six games were decided by one run—one in extra innings.

The seventh game was beyond belief. Giants catcher Hank Gowdy got his foot stuck in his face mask, and two hits bounced over Giants third baseman Fred Lindstrom's head—including the game-winning hit in the 12th inning. The winning pitcher? Walter Johnson. Afterward, commissioner Kenesaw Mountain Landis watched the celebrating Washington fans and said, "Are we seeing the high point of this thing we love? Are we looking at the crest of the institution we know as professional American baseball?"

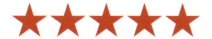

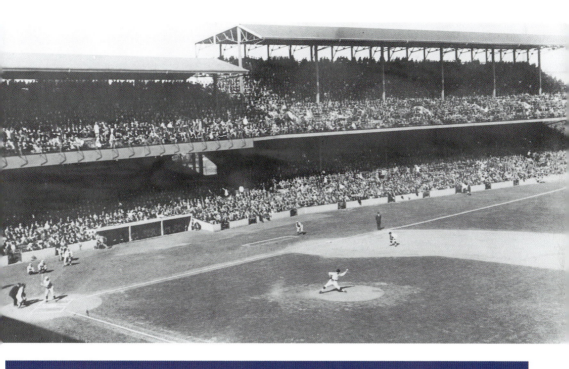

Game 1	New York 4 at Washington 3 (12)	Game 5	Washington 2 at New York 6
Game 2	New York 3 at Washington 4	Game 6	New York 1 at Washington 2
Game 3	Washington 4 at New York 6	Game 7	New York 3 at Washington 4 (12)
Game 4	Washington 7 at New York 4		

THE DAFFY DIZZY DEAN

"If you say you're going to do it, and you go out and do it, it ain't bragging." Jay Hanna Dean lived by this credo throughout his colorful National League pitching career, and he usually proved it right. He may have lived up to his nickname of "Dizzy" with the humorous way he mangled the English language and cavorted on and off the field, but this was one country boy who could back up his actions, with heroics matched by few performers before or since.

Dubbed "Dizzy" by an Army sergeant for his quirky way of viewing the world, the right-hander was already making headlines for showing up late, trash-talking veterans, and striking out batters in bunches by the time he reached his first spring training with the Cardinals in 1931. Within two years, at the ripe age of 22, he was a 20-game winner and

owned the major-league strikeout record with 17 whiffs in one game.

Dean really hit his prime in 1934, the year brother Paul ("Daffy") joined him in the Cardinals rotation. "Me 'n Paul will win 45 games," Dizzy boasted, and while some scoffed, the duo was more than up to the task. Paul went 19–11, and his "veteran" brother was 30–7, despite twice holding sit-down strikes— once to get Paul a raise on his $3,000 salary. In September, the Deans started both ends of a doubleheader against Brooklyn. Dizzy held the Dodgers hitless until the eighth inning before settling for a three-hitter, but when Paul threw a no-hitter in the nightcap, Dizzy told writers, "Gee, if I'd known Paul was gonna do it, I'd done it too."

The Deans each won two games in the World Series for the victorious Cards

that fall, but Dizzy's days at the top were numbered. A line drive off the bat of Cleveland's Earl Averill in the '37 All-Star Game broke Dizzy's big toe, and by coming back too soon and altering his motion he developed a sore arm. He hung on for a few more years, then turned to a highly successful broadcasting career, where he described how runners "slud into third," mediocre pitchers had "nothin' on the ball 'cept a cover," and weak batters "couldn't get a hit with a hoe." After repeatedly poking fun at the hapless 1947 Browns on radio, he was dared by club president Bill DeWitt to do better. Coming out of a six-year retirement for one day to throw four shutout innings, he proved himself right a final time.

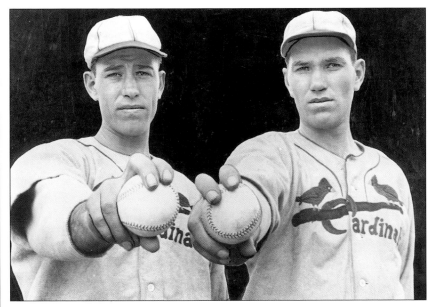

Daffy (left) *and Dizzy Dean*

LEGENDS OF THE HALL

In 1936, baseball came up with the ultimate reward for its stars: a Hall of Fame. The Depression-weary baseball establishment, desperate for a gimmick that might start the turnstiles spinning again, began making plans for the game's 100th birthday. Those plans would link the Centennial with a National Baseball Hall of Fame and Museum in Cooperstown, New York. Two elections were held in 1936 to determine who should be enshrined in the newly created Baseball Hall of Fame: one by the 226 members of the Baseball Writers Association of America; the other by a special, 78-member veterans committee.

Interestingly, no criteria were ever spelled out for what made someone a Hall of Famer. Stats? Character? Winning? A combination? It just seemed obvious; anyone could tell who was a Hall of Famer and who wasn't. The only five able to muster the required 75 percent of either committee's vote were all retired players. No fan could argue with the choices: Ty Cobb (222 votes), Babe Ruth and Honus Wagner (215 each), Christy Mathewson (205), and Walter Johnson (189). In the next three years, 21 more men were chosen in additional elections, from Nap Lajoie and Pete Alexander to Wee Willie Keeler and George Sisler. Today, the bronze plaques that hang in the Hall of Fame gallery immortalize more than 350 of baseball's greatest stars.

Ten of the eleven living Hall of Fame inductees in 1939: (back row, from left) Honus Wagner, Grover Cleveland Alexander, Tris Speaker, Nap Lajoie, George Sisler, Walter Johnson; (front row, from left) Eddie Collins, Babe Ruth, Connie Mack, Cy Young.

MEMORABLE MOMENT

After chasing Ty Cobb's career hit record (4,191) for years, Cincinnati's Pete Rose broke the hallowed mark at home on September 11, 1985. Riverfront Stadium erupted when he lined a single to left-center off San Diego's Eric Show. While hugging first base coach

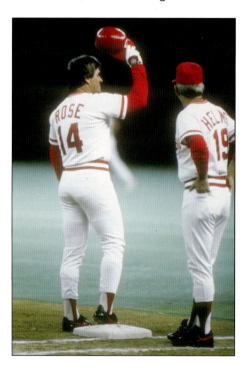

Tommy Helms, the new hit king broke into tears. Afterward, Rose said he would have maintained his composure if the fans hadn't cheered for so long.

SHE FANNED THE BABE

Though Babe Ruth and Lou Gehrig were two of baseball's greatest hitters, a woman once struck them out. It happened in 1931, when the Yankees stopped in Chattanooga en route from spring training camp. Joe Engel, owner of the independent team there, had a widespread reputation for innovative ideas, but this one was the topper. He unveiled a local pitching phenomenon named Jackie Mitchell, who proceeded to strike out Ruth and fellow slugger Lou Gehrig—a feat that made national headlines.

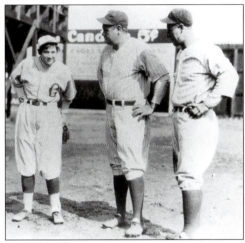

Jackie Mitchell, Babe Ruth, and Lou Gehrig

JACKIE ROBINSON

Statistics don't always do great players justice, but in Jackie Robinson's case numbers are almost irrelevant. Sure, Robinson was a lifetime .311 hitter who spearheaded six pennants and a world championship for the Brooklyn Dodgers, but it was as a crusader for his and all people 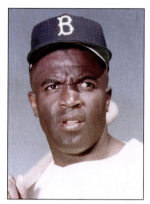 that Jackie stood out. Long after his statistics are forgotten, he will continue to stand as one of the most significant figures in American history.

Born in a shack on a Georgia cotton field, this grandson of a slave and son of sharecroppers was UCLA's first four-sport star before he enlisted in the Army during World War II. After his discharge, Robinson joined the Kansas City Monarchs of the Negro Leagues as debate over the major-league color ban increased. One of three players given a sham tryout by the Boston Red Sox in April 1945, Jackie received a far more sincere gesture from Dodgers general manager Branch Rickey a few months later—a contract making him the first black player signed by a major-league organization in more than half a century. Why Robinson? Because Rickey saw in Jackie the blend of intelligence, character, and iron will needed to endure the challenges ahead.

After leading the International League in batting (.349) for minor-league Montreal in '46, Jackie made the Dodgers the following spring. As a rookie, he was taunted, spiked on the bases, and thrown at by racist pitchers. But true to his word to Mr. Rickey, Robinson stayed calm and let his play do the talking.

It spoke loud and clear, as Robinson electrified crowds with his running (a league-high 29 steals) and production (.297 with 12 homers and 125 runs scored). The Dodgers won the pennant and set an NL attendance record, and Jackie was voted the first National League Rookie of the Year. Teammates who once considered passing a petition against his playing now defended him in on-field incidents, and Robinson grew into a leadership role on one of the finest clubs in Brooklyn history.

Jackie became an outstanding defensive second baseman who led the National League in double plays four straight years, and he had 19 career steals of home—once stealing his way around the bases to get there. In 1949 he won the NL MVP Award, leading the league in batting (.342) and steals (37) while scoring 122 runs and driving in 124. He averaged .329 with 108 runs and 93 RBI from 1949 to '53 before retiring three years later.

Robinson spoke out against injustice until diabetes cut him down in 1972 at age 53. In his autobiography, published just after his death, Robinson stated that as a black American he "never had it made," but what he endured and what he achieved made it easier for those who followed.

> "Those who tangled with him always admitted afterward that he was a man's man, a person who would not compromise his convictions."
> —Baseball writer **Wendell Smith** on Robinson, *Baseball Digest,* January 1973

MAJOR LEAGUE TOTALS									
BA	G	AB	R	H	2B	3B	HR	RBI	SB
.311	1,382	4,877	947	1,518	273	54	137	734	197

JOHNNY BENCH

Named the starting catcher on major-league baseball's All-Century Team, Johnny Bench had it all: size, strength, quickness, and a terrifying arm.

He invented the art of one-handed catching, the perfect style to gun down the newer and faster base stealers of his era.

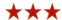

The much-honored catcher was named Rookie of the Year in 1968, was elected to 14 All-Star Teams, took home 10 consecutive Gold Glove Awards (1968–1977), and earned NL MVP honors in 1970 and '72.

Bench, who led the Reds to four World Series and two world titles (1975 and '76), set the major-league record for career home runs by a catcher during his 17 seasons with Cincinnati.

MAJOR LEAGUE TOTALS									
BA	G	AB	R	H	2B	3B	HR	RBI	SB
.267	2,158	7,658	1,091	2,048	381	24	389	1,376	68

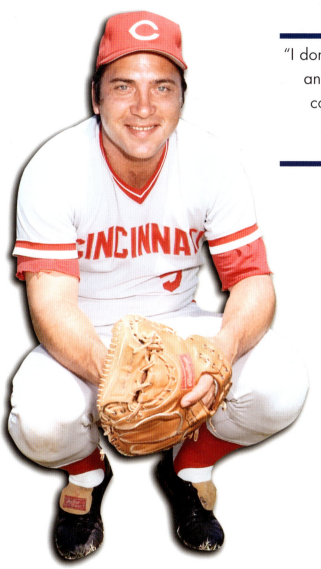

"I don't want to embarrass any other catcher by comparing them to Johnny Bench."

—**Sparky Anderson**

MEMORABLE MOMENT

In 2017 Cleveland caught fire late in the summer. They not only set an American League record with 22 straight wins, they did so in dramatic fashion in front of their home crowd. Jay Bruce's 10th-inning, walk-off double beat Kansas City, 3–2, on September 14 and moved Cleveland past the 21-game win streak of the Chicago White Stockings back in 1880—behind only a Major League-record 26-game surge by the 1916 New York Giants.

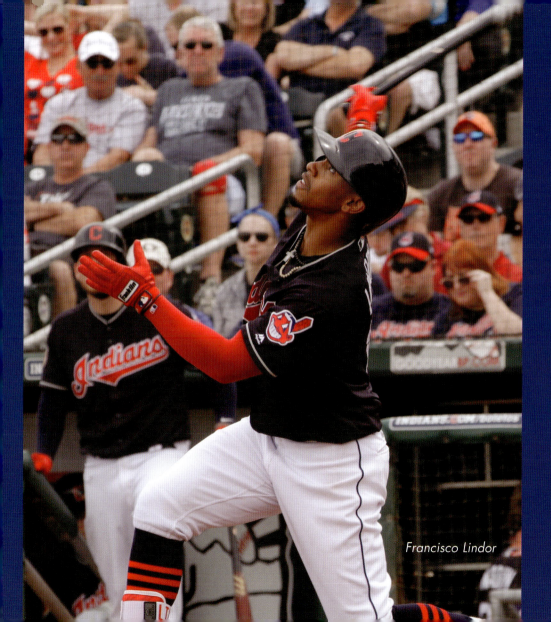
Francisco Lindor

1947: Yankees vs. Dodgers

This Series matched two teams that were each beginning a string of greatness. The Yanks of Babe Ruth and Lou Gehrig were gone; in their place were Joe DiMaggio, Yogi Berra, and Phil Rizzuto. The Dodgers were about to become one of the greatest bunches in National League history. It was Jackie Robinson's first season; Pete Reiser and Pee Wee Reese were blossoming stars.

The most sensational game was the fourth, won by Brooklyn. With two out in the last of the ninth, pinch hitter Cookie Lavagetto cracked the only hit the Dodgers had all game. But it was enough to score two men who had walked, giving Brooklyn a 3–2 win. The Dodgers won Game 6 thanks to outfielder Al Gionfriddo's spectacular catch, but New York took the finale 5–2.

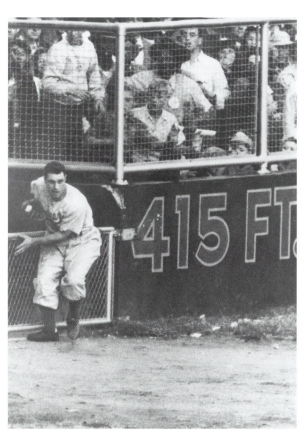

Al Gionfriddo

Game 1	Brooklyn 3 at New York 5
Game 2	Brooklyn 3 at New York 10
Game 3	New York 8 at Brooklyn 9
Game 4	New York 2 at Brooklyn 3
Game 5	New York 2 at Brooklyn 1
Game 6	Brooklyn 8 at New York 6
Game 7	Brooklyn 2 at New York 5

Built in 1914, Wrigley Field is the second-oldest park in the Majors. And more than 100 years after opening, in 2016, it earned the right to fly a World Series championship banner by virtue of hosting the best team in baseball. The ivy-covered walls, old-time scoreboard, and rotation of celebrities singing "Take Me Out to the Ballgame" have always attracted one of the most passionate fan bases in all of sports. Those fans—even the ones who watch from the high rooftops across the street—now benefit from ownership's commitment to improving not only the product on the field, but also the North Side's hallowed facility—known to the Cubs and their fans as "The Friendly Confines."

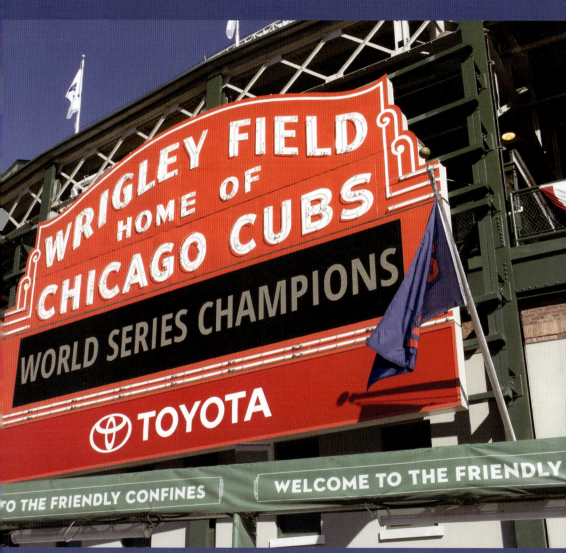

MOST MANAGERIAL WINS

1.	**Connie Mack**	3,731
2.	**Tony La Russa**	2,884
3.	**John McGraw**	2,763
4.	**Bobby Cox**	2,504
5.	**Joe Torre**	2,326
6.	**Sparky Anderson**	2,194
7.	**Dusty Baker**	2,183
8.	**Bruce Bochy**	2,171
9.	**Bucky Harris**	2,158
10.	**Joe McCarthy**	2,125

Connie Mack

"Well, you can't win them all."

—Connie Mack

on his 1916 A's, who went 36–117

CHRISTY MATHEWSON

On major-league career lists, Mathewson ranks third in wins (373), third in shutouts (79), and eighth in ERA (2.13).

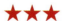

The right-handed screwballer won at least 22 games for the New York Giants for 12 consecutive seasons, including 30 or more wins in 1903, '04, '05, and '08.

In four World Series, Mathewson notched 10 complete games, including three shutouts in the 1905 season.

The clean-cut, deep-thinking college man was renowned for his intelligence, class, and fadeaway fastball. Worshipped nationwide, he was considered a fine example for a game that was cleaning up its image.

MAJOR LEAGUE TOTALS									
W	L	ERA	G	CG	IP	H	ER	BB	SO
373	188	2.13	635	434	4,780.2	4,218	1,133	844	2,502

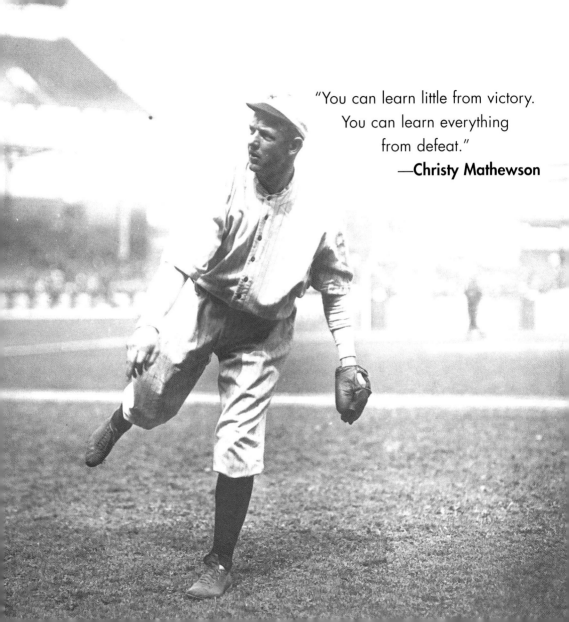

"You can learn little from victory.
You can learn everything
from defeat."

—Christy Mathewson

A FULL COUNT

★★★★
THE GAME'S GREATEST UMPIRES

Al Barlick
Nestor Chylak
Tom Connolly
Billy Evans
John Gaffney
Doug Harvey
Cal Hubbard
Bill Klem
Tim McClelland
Bill McGowan

Most baseball historians agree that Bill Klem was the greatest umpire ever. In fact, he was so good at calling balls and strikes that for 16 years they wouldn't let him umpire the bases, putting him behind the plate for every game he refereed. For 37 years, he was the best. When Klem retired in 1941, he was put in charge of all National League umpires in hopes he would pass his skills and attitude along to them.

"It ain't nothing till I call it."
—**Bill Klem**

MEMORABLE MOMENT

In 1939 Yankees slugger Lou Gehrig was diagnosed with amyotrophic lateral sclerosis, an incurable disease that would one day bear his name. On July 4 that year, New Yorkers saluted Gehrig in a sold-out tribute ceremony at Yankee Stadium. Tears flowed as Gehrig addressed the crowd: "Fans, for the past two weeks you have been reading about the bad break I got. Yet today I consider myself the luckiest man on the face of the earth."

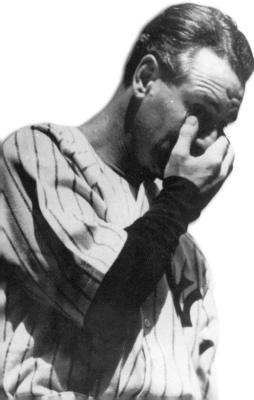

CAREER SAVE LEADERS

* entering 2025 season

1. **Mariano Rivera** — 652
2. **Trevor Hoffman** — 601
3. **Lee Smith** — 478
4. **Kenley Jansen** — 447
5. **Craig Kimbrel** — 440
6. **Francisco Rodríguez** — 437
7. **John Franco** — 424
8. **Billy Wagner** — 422
9. **Dennis Eckersley** — 390
10. **Joe Nathan** — 377

Trevor Hoffman

ORACLE PARK, SAN FRANCISCO

The home of the "Splash Hit," Oracle Park is an architectural marvel and one of the most scenic places in the world to view a sporting event. In addition to watching those rare splash hits (home runs that soar out of the park and into McCovey Cove beyond right field) fans enjoy spectacular views across San Francisco Bay, and can even (if you're young enough) slide down a giant Coke bottle. Throw in delectable food items ranging from top-grade sushi to Gilroy garlic fries, and a day at this ballpark can truly have fans leaving their hearts in San Francisco.

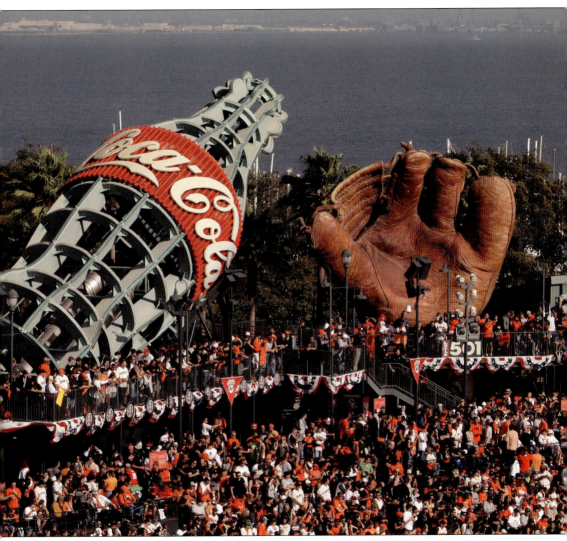

WILLIE MAYS

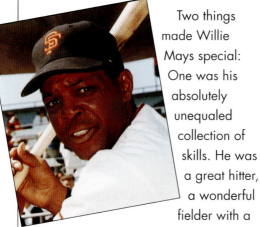

Two things made Willie Mays special: One was his absolutely unequaled collection of skills. He was a great hitter, a wonderful fielder with a super arm, a sensational slugger, and a base runner of blazing speed and daring. Sure, for each of those talents there was someone who did it better. But no one else combined all of those abilities to such a degree. The other, equally magical side of his playing style was his childlike enthusiasm and love of the game. Willie wasn't beating you to show you up; he was clobbering you because it was so much fun. He flew out from under his cap as he ran. He chased down fly balls with not only pure speed but also genuine exuberance. His trademark greeting, "Say hey!" somehow communicated his delightful attitude.

Mays was among the last Negro Leaguers to make the majors. He emerged as a 20-year-old New York Giant in 1951. Rookie of the Year (.274, 20 homers) on the National League champions, he missed most of the next two years fulfilling military obligations. He returned in '54, rippling with new muscle and ready to wreak havoc on NL pitching, and his incredible Hall of Fame career was off and running.

Willie Mays wasn't just great, he was durable as well: His string of 13 consecutive 150-game seasons is an all-time record. Every year Willie's name was at the top of one or another statistical category: triples or homers (four times);

batting or slugging average; runs, hits, or walks. He was chosen as league MVP twice. As the best of the best, it made sense that every year Willie made the All-Star Game his own personal showcase. It was a treat that fans of the era anticipated and savored. He seemed to be in the middle of every important play in the midseason classic—cracking a key double, stealing a vital base, or making a critical circus catch.

Willie's over-the-shoulder catch of Vic Wertz's 430-foot smash to center in the '54 World Series has been called the greatest grab of all time, and it brought into national focus another key aspect of Mays's game: his defense. Willie won a

> "The only man who could have caught it, hit it."
> —Sportswriter **Bob Stevens** after Mays belted a drive over the center fielder's head

Gold Glove each of the first 12 years in which the trophy was awarded, routinely turning in fantastic plays. He patented a flashy, one-handed basket catch, and—even with runners wary of testing his arm—recorded 12 or more assists on nine occasions.

By the time he retired he had hit more home runs (660) than anyone besides Babe Ruth. And Willie had lost two seasons to military service, too. Many baseball experts have called him the greatest player ever. Actress and baseball devotee Tallulah Bankhead once said, "There have been only two authentic geniuses in the world, Willie Mays and Willie Shakespeare." Who could argue with that?

MAJOR LEAGUE TOTALS									
BA	G	AB	R	H	2B	3B	HR	RBI	SB
.302	2,992	10,881	2,062	3,283	523	140	660	1,903	338

JOINING RUTH IN THE HISTORY BOOKS

The most immortal name in baseball—the "Babe"—does not get tossed around lightly a century after George Herman Ruth's exploits. Never, however, has it come up more in conversation than since Shohei Ohtani arrived in the Majors in 2018.

That's because Ohtani is that rare player who pitches and hits at the highest level. With the Angels, he won two American League MVP Awards, became the first man in the modern era to rank among league leaders as both a pitcher and hitter, and was the first Japanese player to win a home run title. However, he was only warming up for what 2024 would bring.

Ohtani added a NL MVP Award to his resume when, in his debut with the Dodgers, he won a World Series title and created his own "50–50 club" as the only player in MLB history with 50 homers and 50 steals in one season.

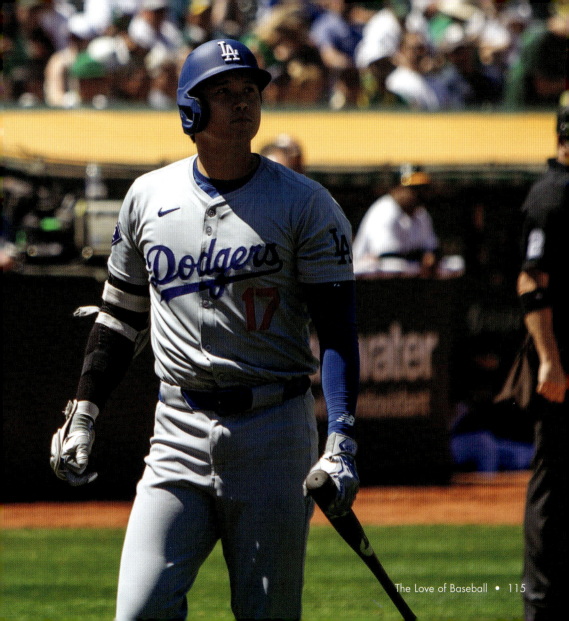

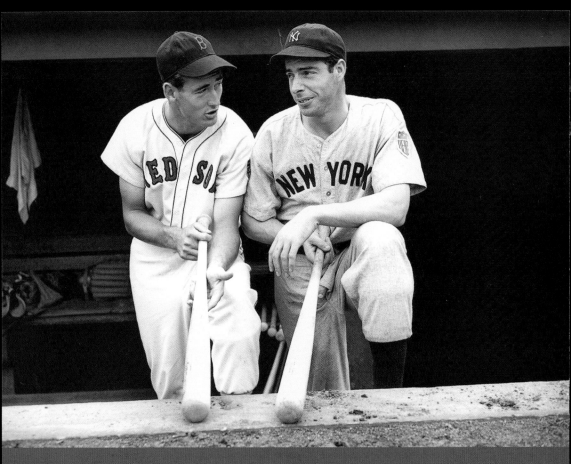

Ted Williams and Joe DiMaggio were baseball's shining stars throughout the '40s. In '49, there were reports the heavy hitters would be traded for each other, but the Yankees declined when the Red Sox wanted Yogi Berra included in the deal.

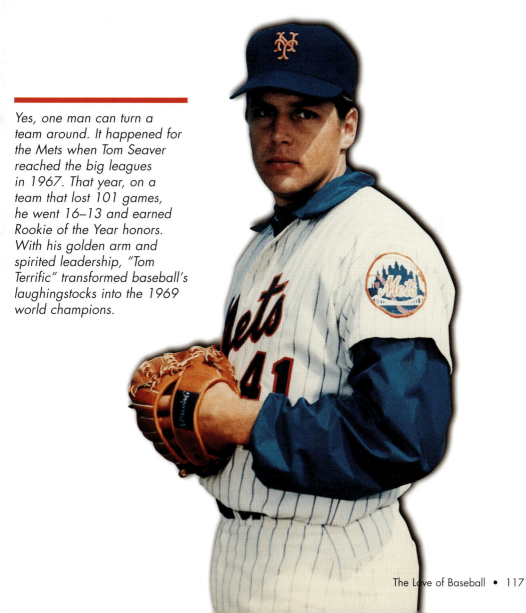

Yes, one man can turn a team around. It happened for the Mets when Tom Seaver reached the big leagues in 1967. That year, on a team that lost 101 games, he went 16–13 and earned Rookie of the Year honors. With his golden arm and spirited leadership, "Tom Terrific" transformed baseball's laughingstocks into the 1969 world champions.

MEMORABLE MOMENT

In 1961 not one but two men were in full rush to bust the Babe's single-season home run record: Yankee sluggers Mickey Mantle and Roger Maris. While New York's fans and reporters didn't mind if the charismatic Mantle broke the fabled Bambino's record, they gave Maris a hard time—booing him and browbeating him with questions. By late August, injuries had knocked Mantle off the pace, and he finished the season with 54 homers while Maris went on to the promised land. Despite insomnia and nightmares, Maris persevered. In the season's final game, he belted No. 61 against Boston at Yankee Stadium.

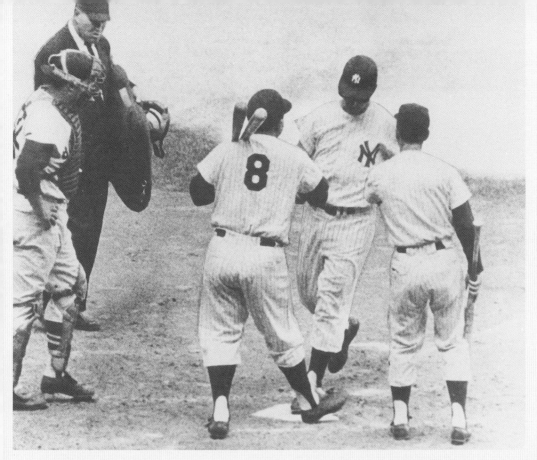

While hitting a then-record 61 homers for the New York Yankees during the 1961 season, Roger Maris never received an intentional walk; Mickey Mantle was batting behind him.

SATCHEL PAIGE

Paige, hailed as the greatest Negro League pitcher of all time, achieved such feats as 64 consecutive scoreless innings, 21 straight wins, and a 31–4 record for the Pittsburgh Crawfords in 1933.

The right-handed fireballer claimed he tossed 55 no-hitters and approximately 300 shutouts in his lifetime.

When he finally was brought to the Majors in 1948, he went 6–1 with a 2.48 ERA as a 42-year-old rookie, helping Cleveland win their first world title since 1920.

In 1965, at age 59, Paige pitched three shutout innings for the Kansas City Athletics, becoming the oldest man ever to pitch in the majors.

MAJOR LEAGUE TOTALS									
W	L	ERA	G	CG	IP	H	ER	BB	SO
28	31	3.29	179	7	476.0	429	174	183	290

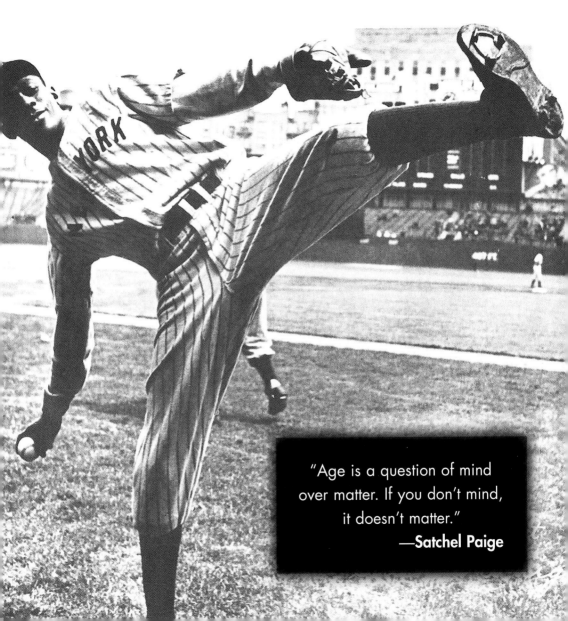

"Age is a question of mind over matter. If you don't mind, it doesn't matter."
—**Satchel Paige**

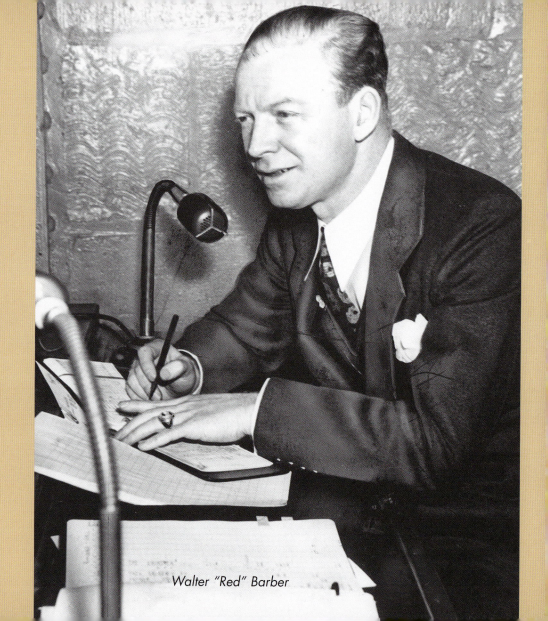

Walter "Red" Barber

BASEBALL ON THE RADIO

They say that during summer in the 1940s, a baseball fan could walk along Flatbush Avenue in Brooklyn and never miss an inning of a Dodgers game. The radio broadcasts could be heard through the open windows of apartment buildings and local merchants. Such was the power—and magic—of baseball on the radio. Red Barber, Mel Allen, Jack Buck, Vin Scully, and Ernie Harwell were some of the great announcers as the golden age of radio and baseball meshed. Their voices filled homes throughout each summer as they became the daily companions of the true baseball fan. Even today, many fans still recall their greatest baseball memories in the way in which the radio broadcasters described them.

Famed for ballparks like Ebbets Field and Yankee Stadium, New York City welcomed two new ones to its landscape in 2009. Well, perhaps two new ones is a misnomer. One was a "new" and improved Yankee Stadium—built one block north of the original and with an architectural plan staying true to the classic park in several facets. At the time it opened, its $2.3 billion price tag made it the most expensive sports stadium ever constructed. Across town in Queens, the Mets moved into a sparkling new home the very same year. Replacing Shea Stadium, Citi Field was a relative bargain at less than $1 billion. The exterior of the park brings back memories of classic Ebbets Field and the seats were all painted green in honor of another old New York ballpark—the Polo Grounds. Everything old, it seems, becomes new again.

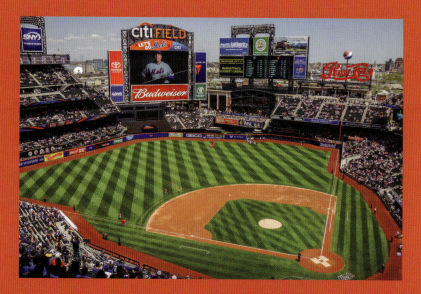

(Left) *Citi Field*
(Right) *Yankee Stadium*

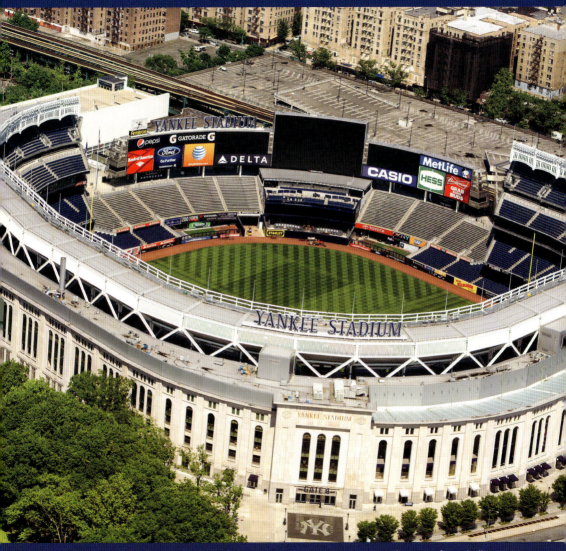

NO EXCUSES

"I wanted to be like Nolan Ryan. I didn't want to be like Pete Gray."

Such were the boyhood dreams of Jim Abbott, who sought a baseball career despite having a right arm that ended just above the wrist. Abbott had no intention of making the majors as an oddity. He yearned to succeed on his talent alone, and in the end he would do so—but not without becoming a reluctant hero.

Abbott taught himself to transfer his glove from his left arm to his right by throwing against a brick wall. He later said that his missing hand "wasn't really an issue when I was a kid." By becoming an expert fielder, he kept hitters from using the logical tactic of bunting against him to their advantage. During his college career he racked up a 26–8 record at the University of Michigan, took home the Sullivan Award in 1987 as the nation's best amateur athlete, and won a gold medal in the 1988 Olympics.

California's No. 1 pick in the 1988 draft, Abbott became one of a few players in history to completely bypass the minor leagues, then he overcame a media circus to go 12–12 as a rookie with the 1989 Angels. More great moments would follow—including a 1993 no-hitter for the Yankees—and it wasn't long before he had gotten his wish. He was simply Jim Abbott—pitcher.

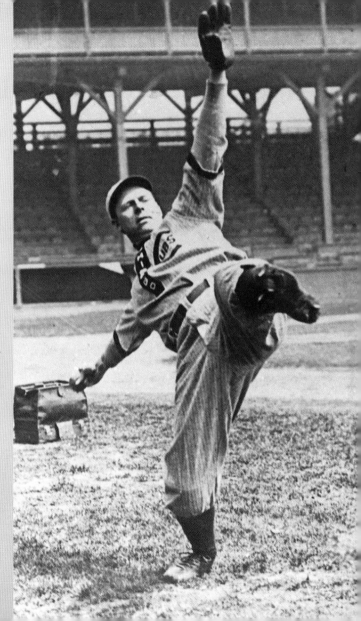

"To know for sure, I'd have to throw with a normal hand, and I've never tried it."
—**Mordecai "Three Finger" Brown**, when asked if his curveball was aided by the mangled fingers on his pitching hand

SEALING THE DEAL

★★★★
BASEALL'S BEST CLOSERS

Dennis Eckersley
Rollie Fingers
John Franco
Eric Gagne
Goose Gossage
Trevor Hoffman
Mariano Rivera
Lee Smith
Bruce Sutter
Hoyt Wilhelm

Personal problems kept Dennis Eckersley from stardom as a starting pitcher during his first 12 years in the majors. But he put his demons behind him and moved into the bullpen, where he can lay claim to being the greatest closer ever. From 1988 to '92, he rang up 220 saves and 24 wins with just nine losses, and he struck out 378 while walking only 38. In 1989 and '90 combined, he amassed more saves (81) than hits allowed (73)—and he walked just seven batters!

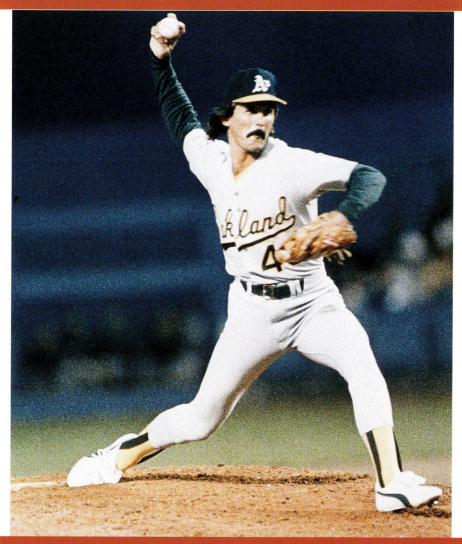

WALTER JOHNSON

The Cy Young Award is given annually to the best pitcher in each league, which is ironic considering it isn't even named for the finest pitcher of all time. Sure, Young had more wins than any major-leaguer with 511. But as Cy's time was winding down around 1910, another hurler was just getting started with the old Washington Senators. And before he was through 21 years later, Walter Perry Johnson would be heralded as one of the game's grandest gentlemen—and the greatest pitcher of them all.

The son of Kansas farmers, Johnson was discovered playing for a semipro team in Idaho and was dispatched on a train to Washington—and the major leagues. A long-limbed right-hander with an easy delivery, the 19-year-old could throw a 100-mph fastball. He struggled to learn on the job, however, going 32–48 over his first three years with teams that never rose above seventh place.

More comfortable with his role as Washington's ace by 1910, Johnson had his first spectacular season with a 25–17 record, 1.35 ERA, and 313 strikeouts for the seventh-place Senators. In a pattern that would repeat itself many times, the man nicknamed "Big Train" after the freewheeling locomotives of his day was a frequent victim of nonsupport from his light-hitting mates. He eventually would amass a record 64 contests decided by a 1–0 score—winning 38 of them.

The Senators showed dramatic improvement over the next few years,

and Johnson anchored second-place finishes in 1912 and '13 with records of 33–12 and 36–7. The latter season may have been the finest performance ever by a major-league hurler. It included such glittering numbers as a 1.14 ERA, 11 shutouts, and five one-hitters. Those who claim Sandy Koufax's 1962 to '66 binge was the finest five-year stretch in history should view Johnson's work from 1912 to '16: a 149–70 record, an ERA below 1.90 each season, 1,202 strikeouts, and just 326 walks over 1,794 innings. Eventually, Johnson would pace the AL 12 times in strikeouts, six times in wins, and five times in ERA.

Washington slipped back to the second division as the years wore on, finishing with a winning record in just four seasons from 1914 to '23.

Walter still put together six consecutive 20-win campaigns during those years, and then, at age 36, enjoyed the most satisfying year of his career: In 1924 he led the league with a 23–7 record, 2.72 ERA, and 158 strikeouts, then capped it off by winning the seventh game of the only victorious World Series in Senators history.

Two more seasons and another World Series appearance remained before a broken leg derailed Johnson's career, but by then he had racked up 417 wins (second only to Young), a 2.17 ERA, and 3,509 strikeouts (a record that stood for more than 50 years). Shutouts? Johnson compiled a record 110 of them, 34 more than a guy named Young.

> "You can't hit what you can't see."
> —**John Daley** of the St. Louis Browns
> after pinch-hitting against Johnson

MAJOR LEAGUE TOTALS									
W	L	ERA	G	CG	IP	H	ER	BB	SO
417	279	2.17	802	531	5,923.0	4,927	1,424	1,362	3,509

Due to injuries to both legs, Dodgers slugger Kirk Gibson didn't dress for Game 1 of the 1988 World Series. But when Los Angeles fell behind Oakland 4–3, the team's heart and soul slipped on his uniform and came out to bat. With one on and two outs in the bottom of the ninth, he limped to the plate. Lunging at a Dennis Eckersley pitch, Gibson willed the ball over the right-field fence. A nation looked on in amazement as Gibson limped around the bases, pumping his fist in victory.

"Nobody is half as good as Mickey Mantle."

—**Al Kaline**, responding to a young boy who had said to him, "You're not half as good as Mickey Mantle."

NOTABLE NICKNAMES

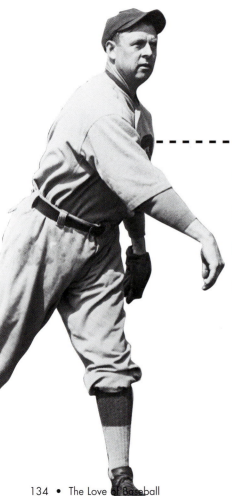

Jimmy "Foxy Grandpa" Bannon

Bill "Ding Dong" Bell

Mordecai "Three Finger" Brown

Buttermilk Tommy Dowd

Piccolo Pete Elko

Phil "Scrap Iron" Garner

Doug "Eyechart" Gwosdz

Mike "The Human Rain

Delay" Hargrove - - - - - - - - -

Charlie "Piano Legs" Hickman - - - - - ┐

Jimmy "The Human Mosquito" Slagle

Bill "Baby Doll" Jacobson

Willie "Puddin' Head" Jones

Wee Willie Keeler - - - - - - - - ┐

Mark "Humpty Dumpty" Polhemus

Shoeless Joe Jackson

CAREER WIN LEADERS

1. **Cy Young** 511

2. **Walter Johnson** 417

3. **Pete Alexander** 373

 Christy Mathewson 373

4. **Pud Galvin** 365

5. **Warren Spahn** 363

6. **Kid Nichols** 361

7. **Greg Maddux** 355

8. **Roger Clemens** 354

9. **Tim Keefe** 342

Roger Clemens

The stellar performance of Warren Spahn and Johnny Sain in 1948 fueled the Braves's drive to the pennant. During one September stretch the duo started 11 of 16 games, going 9–2. "Spahn and Sain and pray for rain" was the rallying cry.

Warren Spahn (left) *and Johnny Sain*

LEFTY GROVE

Robert Moses "Lefty" Grove, who amassed 300 wins with the Philadelphia A's and Boston Red Sox, ended his career with a .680 winning percentage—the best of any 300-game winner in baseball.

The temperamental hurler won the AL "pitching triple crown" in both 1930 (28–5, 2.54 ERA, 209 strikeouts) and 1931 (31–4, 2.06, 175), and he captured nine ERA crowns, more than any other pitcher in history.

From 1928 to 1933, a golden era for hitters, Ol' Mose went 152–41 with a 2.67 ERA. In 1931 he took home the AL MVP crown.

MAJOR LEAGUE TOTALS									
W	L	ERA	G	CG	IP	H	ER	BB	SO
300	141	3.06	616	298	3,940.2	3,849	1,339	1,187	2,266

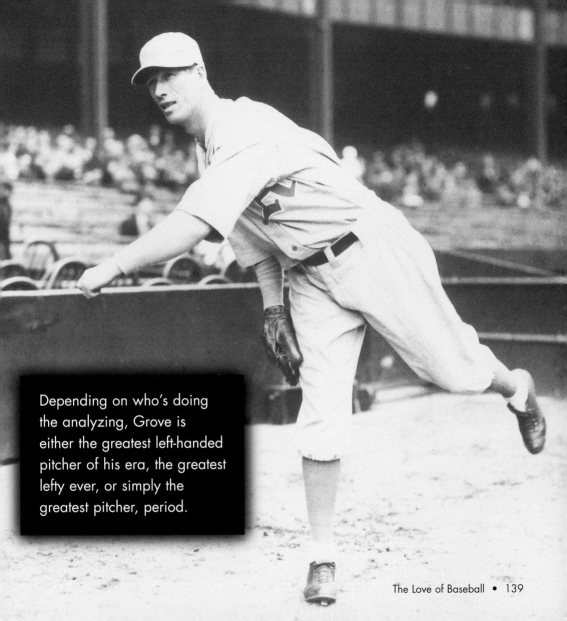

Depending on who's doing the analyzing, Grove is either the greatest left-handed pitcher of his era, the greatest lefty ever, or simply the greatest pitcher, period.

In a publicity stunt hatched by Browns owner Bill Veeck, 43-inch, 65-pound Eddie Gaedel emerged out of a cake wearing uniform number ⅛ and was sent up to pinch-hit against the Tigers on August 19, 1951. Batting out of a crouch, he was walked on four straight pitches.

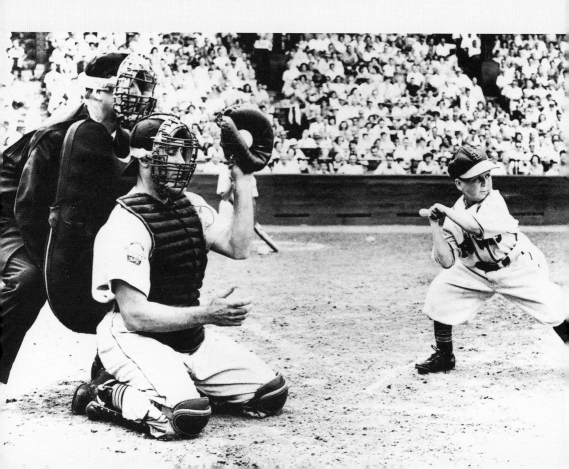

2012: YEAR OF THE PITCHER

Entering 2012, only 20 perfect games had been pitched in well over 100 years of Major League Baseball. In that one season, however, there were three. Throw in four additional no-hitters, and 2012 truly earned its unofficial title: Year of the Pitcher.

Philip Humber of the White Sox got the streak going in April. Matt Cain of the Giants followed in June, and in August it was Félix Hernández of the Mariners. Each of their perfect games were spaced two months apart, as if by design.

1955: Dodgers vs. Yankees

The Yankees had topped the Brooklyn Dodgers in 1949, and the Dodgers narrowly missed reaching the Series in 1950 and '51. When the two teams went head to head in 1952 and '53, the story was the same: the Yanks won.

But the 1955 Dodgers had a new manager, Walter Alston, and a new set of heroes. Duke Snider clubbed four homers in the Series, a feat only Babe Ruth, Lou Gehrig, and Snider himself had previously accomplished. Pitcher Roger Craig stifled the Yanks in Game 5. Johnny Podres won Games 3 and 7. In the Series finale, the Dodgers were hanging on to a 2–0 lead when Sandy Amorós—brought into the game for defensive purposes—made an impossible grab of a tailing Yogi Berra liner and turned a potentially game-tying double into a double play. "Next year" finally had arrived in Brooklyn.

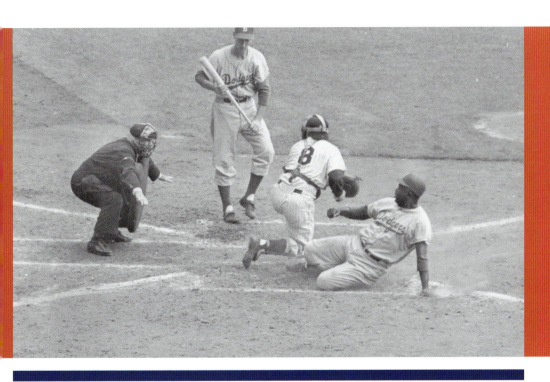

Game 1	Brooklyn 5 at New York 6		**Game 5**	New York 3 at Brooklyn 5
Game 2	Brooklyn 2 at New York 4		**Game 6**	Brooklyn 1 at New York 5
Game 3	New York 3 at Brooklyn 8		**Game 7**	Brooklyn 2 at New York 0
Game 4	New York 5 at Brooklyn 8			

HONUS WAGNER

Often mentioned alongside Ty Cobb as one of the greatest players of the dead-ball era, John Peter Wagner could not have been more different from his contemporary. The pride of the Pirates was a notorious Mr. Nice Guy, as modest and even-tempered as Terrible Ty was vicious and bullheaded. Most famous these days as the guy whose 1910 baseball card could pay for a new house and college education, "The Flying Dutchman" also happened to be a .327 lifetime hitter with a National League–record eight batting titles and 722 stolen bases—as well as the greatest-fielding shortstop this side of Ozzie Smith.

Supposedly discovered throwing coal chunks at a boxcar near his tiny Pennsylvania hometown, Honus joined Louisville of the NL as an outfielder in 1897. Squat (5'11", 200 pounds) and bowlegged with a long, beaked nose, Wagner didn't look like a ballplayer—until he got on a field. Once there, the right-handed, barrel-chested slugger with deceptive speed hit .299 and .336 his first two full seasons, with more than 100 RBI per year.

The Louisville franchise shifted to his hometown of Pittsburgh in 1900, and Wagner celebrated by collecting his first NL batting title with a career-high .381 mark while leading the NL in doubles (45), triples (22), and slugging (.573). League leader in RBI (126 and 91) and stolen bases (49 and 42) each of the

next two seasons, he hit .353 and .330 as the Pirates won back-to-back NL championships.

After playing as many as five positions in a season, Wagner thrived once he was named Pittsburgh's starting shortstop in 1903. Becoming the game's best fielder at the spot, he developed a rifle arm and used his huge hands to scoop up everything hit near him. He also hit .350 with seven batting titles over the next nine seasons, earning the first in '03 when he hit .355 with 101 RBI, 46 steals, and a league-high 19 triples to power the Pirates to their third straight pennant.

Never hitting more than 10 home runs, Wagner paced the league in slugging six times as the classic dead-ball power hitter—leading the NL seven times in doubles, collecting 10 or more triples 13 times, and notching 100 or more RBI on nine occasions, leading the league five times. Stolen-base king five times, he swiped 40 or more over eight straight years.

Retiring at age 43 as the National League leader in hits (3,415), runs (1,736), doubles (640), and triples (252), the charter Hall of Famer still ranks high on each list. He came back at age 59 to coach for the Pirates and stayed on 18 years, spinning many a yarn about the good ol' days and keeping himself young.

> "There is something Lincolnesque about him, his rugged homeliness, his simplicity, his integrity, and his true nobility of character."
> —Sportswriter **Arthur Dale** on Wagner

MAJOR LEAGUE TOTALS									
BA	G	AB	R	H	2B	3B	HR	RBI	SB
.327	2,792	10,430	1,736	3,415	640	252	101	1,732	722

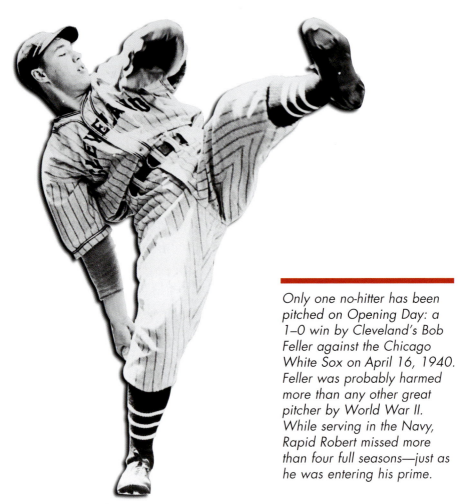

Only one no-hitter has been pitched on Opening Day: a 1–0 win by Cleveland's Bob Feller against the Chicago White Sox on April 16, 1940. Feller was probably harmed more than any other great pitcher by World War II. While serving in the Navy, Rapid Robert missed more than four full seasons—just as he was entering his prime.

FOR OPENERS...

When 20-year-old Bryce Harper homered in his first two at-bats of the 2013 season, he became the youngest player in Major League history to hit two Opening Day homers. As of 2017, Harper had already racked up five Opening Day home runs!

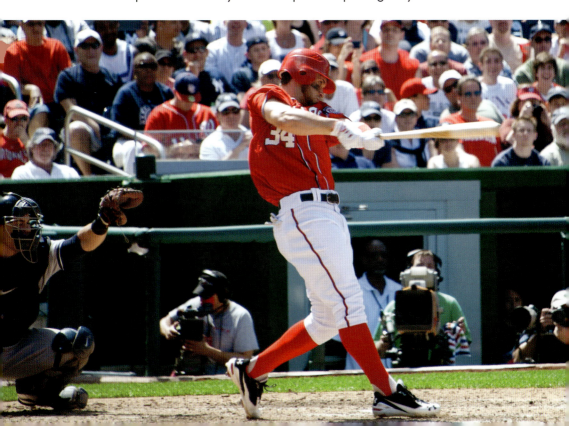

POWER PLAY

During the 2015 season the Cubs's Kyle Schwarber hit a ball so far that it landed atop the right-field scoreboard at Wrigley Field. The Cubs then did what any smart collector would do—they encased the ball in glass and kept it up there! It came down for a while and was placed in safe keeping, but during their 2016 World Series season the team announced the ball was back where it belongs, looking down on its team's climb to the top.

STRONGEST SLUGGERS

Jimmie Foxx

Josh Gibson

Harmon Killebrew

Dave Kingman

Mickey Mantle

Willie McCovey

Mark McGwire

Babe Ruth

Willie Stargell

Jim Thome

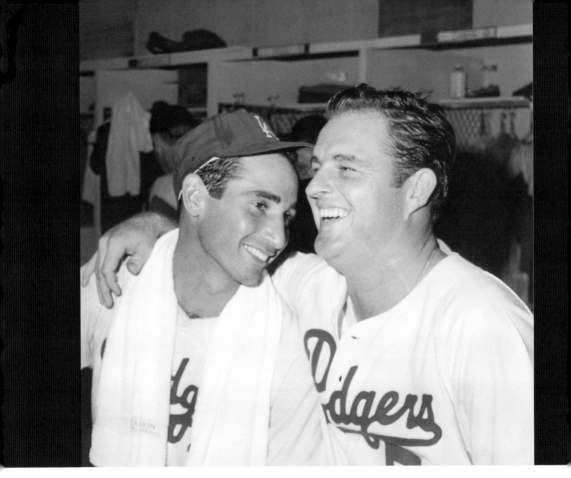

In 1965, Sandy Koufax (*left*) and Don Drysdale accounted for 49 of the
Dodgers's 97 wins, including (*here, postgame*) a pennant-clincher by Koufax
over the Braves on October 2.

MAD SKILLS

San Francisco ace Madison Bumgarner was already considered one of the best hitting pitchers in the game. He added to his legend in 2017 when he became the first pitcher in history to launch two Opening Day home runs.

THROWING SMOKE

A pitcher named Steve Dalkowski was one of the hardest throwers in the history of baseball. Even those who saw Nolan Ryan and Bob Feller were convinced. However, because he never played in the Majors and pitched well before the radar gun came around, legend is really all we have to go on. In the Minors, Dalkowski is said to have torn the ear off a batter with one pitch and shattered an umpire's mask with another.

These days, Aroldis Chapman holds the distinction of baseball's fastest heater. He first set the radar gun record when, pitching for Cincinnati in 2010, he clocked 105.1 mph. He matched that mark in 2016 while pitching for the Yankees. In fact, in counting the total number of 100-plus mph pitches ever thrown by left-handers, Chapman owns almost all of them. In 2024 Ben Joyce of the Angels climbed to third place with a pitch clocking in at 105.5 mph.

With a blistering 100-mph fastball, Randy Johnson shattered bats and once even accidentally exploded a bird in flight. From 1997 through 2002, he went 120–42, averaged 340 strikeouts, and won four Cy Young Awards. He holds the record for highest career strikeouts by a left hander.

CROSSING HOME

"After I hit a home run I had a habit of running the bases with my head down. I figured the pitcher already felt bad enough without me showing him up rounding the bases."

—Mickey Mantle

A BREAKTHROUGH BLEND

Braves skipper Brian Snitker once told his great young outfielder, Ronald Acuña Jr., "If I could run like you, I'd sell my car." Turns out the Venezuelan dynamo wields quite a bat, too, quickly becoming a dual speed-and-power threat the likes of which baseball has seldom seen.

Acuña burst onto the Major League scene at just 19 years old, garnering the 2018 National League Rookie of the Year honors. Things would just keep getting better after entering his 20s.

Ronald was selected to the MLB All-Star Game for the first time in 2019, and in 2023 was a unanimous choice as National League MVP when he accomplished something never before done in the Majors—compiling 40 home runs and 70 stolen bases in the same season. He led the NL that year in hits (217), steals (73), runs (149) and total bases (383).

LIMITING THOSE EXTRA FRAMES

It's highly unlikely the Major's more-than-a-century-old record for longest game by innings (26) will ever be broken. That's because of a rule implemented during the 2020 (COVID-19) season that has every regular-season extra inning starting with a runner on second base.

Designed to end games sooner and thus preserve pitching arms, the rule was kept in place in 2021 and 2022. The Joint Competition Committee then voted to make it a permanent fixture of the rulebook beginning in 2023. The rule does not apply to postseason games.

Long extra-inning games have become almost obsolete as a result. In the first three seasons the rule was in place, just seven games lasted as long as 13 innings. In 2019, the last year before the rule, there were 37 such games. In fact, when the Dodgers and Padres played a 16-inning marathon under the rule in 2022, it topped any game of the previous two seasons by three innings. It looks like the change has been a worthwhile success.

PERSONALITY PLUS

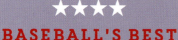

Yogi Berra's marvelous, sometimes uproarious, nearly Zen (but not quite) "Yogi-isms" are inextricably intertwined with baseball lore. These *bons mots* often showcase a mind with a keen understanding of the game. Not many people remember that the Yankees catcher who pronounced the deep truth about baseball—"It ain't over till it's over"—left the historic third game of the 1951 National League playoffs in the eighth inning.

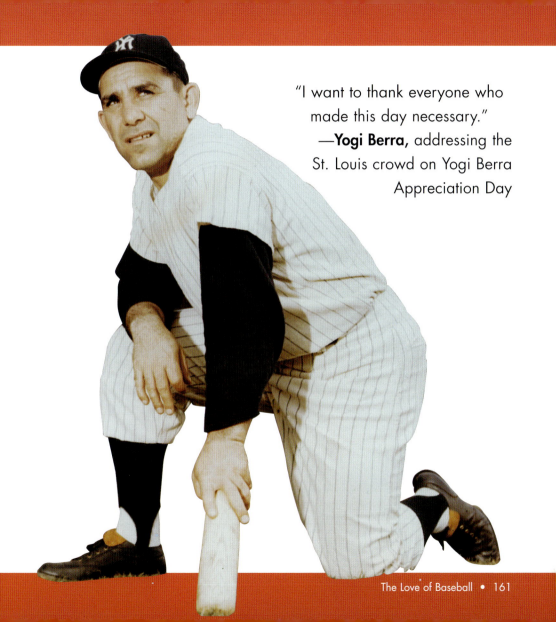

"I want to thank everyone who made this day necessary."
—**Yogi Berra,** addressing the St. Louis crowd on Yogi Berra Appreciation Day

STENGELESE

The lexicon of baseball is filled with catchy phrases. A lazy fly ball is known as a "can of corn." A double play is often described as a "twin killing," and runners on base are also known as "ducks on the pond." But for decades Casey Stengel and Yogi Berra spoke their own brand of baseball language. They were masters of the malaprop and the mixed metaphor. When Casey went on a rant, it was known as Stengelese. When Berra offered advice, it was a Yogi-ism.

Stengel managed his share of miserable teams, including the 1934–36 Dodgers, 1938–43 Braves, and 1962–65 Mets. But his legacy also includes the 1949–60 New York Yankees, whom he managed to ten pennants. During this time he became known as the "Ol' Perfessor." Warren Spahn pitched for Stengel with both the Braves and the Mets, prompting him to note that he played for Casey "both before and after he was a genius."

Classic Stengelese

Stengel called rookies "green peas," a good fielder was a "plumber," and a tough ballplayer was someone who could "squeeze your earbrows off."

"Good pitching will always stop good hitting and vice versa."

"I don't know if he throws a spitball, but he sure spits on the ball."

"Being with a woman all night never hurt no professional baseball player. It's staying up all night looking for a woman that does him in."

Casey Stengel (left) *with Yogi Berra*

MICKEY MANTLE

The New York Yankees all but ruled baseball from 1920 to 1964, and Mickey was the last representative of the line of superheroes who anchored the team: Ruth, Gehrig, DiMaggio, and the Mick. Before his rookie season, manager Casey Stengel, usually circumspect when stating a player's skills, was unequivocal about the kid's prospects. "He should lead the league in everything. With his combination of power and speed he should win the triple batting crown every year. In fact, he should do everything he wants to do."

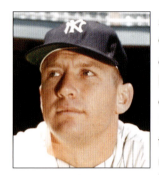

Mickey Charles Mantle was something special indeed: an amazing combination of power, speed, and presence—the golden boy of New York (and all of baseball, for that matter). A switch-hitter from Commerce, Oklahoma, Mantle overcame a bone disease in his left leg to make the Yankees as a 19-year-old outfielder in 1951. He recovered from a tough start to deliver a fine rookie year dimmed only by an injury to his good leg sustained in the Yankees' World Series win over the Giants. It was just the start of the health hazards that would plague Mantle's career. But as the starting center fielder on the most dominating team in baseball history, Mantle's star rose quickly. He batted .311 his second season, and he led the American League with 37 home runs in 1955.

Superb defense, blistering power (the term "tape-measure home run" was coined after his 565-foot shot at Washington), and annual totals of

100-plus runs and 90-plus RBI were not enough for some fans awaiting the next DiMaggio. Only after putting together an MVP/Triple Crown season in 1956 (pacing the league with a .353 average, 52 homers, 130 RBI, 132 runs, and .705 slugging percentage) did Mantle win everyone over. He cracked a career-high .365 with 34 home runs to cop a second straight MVP trophy in '57, and in 1961 he waged a season-long assault against Babe Ruth's record of 60 homers. He wound up six short when he was sidelined in September by a hip infection, and teammate Roger Maris then heard the booing not only for challenging Ruth but also for outdoing Mantle.

> "He is the kind of ballplayer who is so good…it makes everybody want to follow his example."
> —**Elston Howard** on longtime Yankee teammate Mickey Mantle

When he recovered to win a third MVP prize in '62 (.321–30–89), many still thought he might challenge Ruth's all-time record of 714 homers. But injuries (including surgery on one shoulder and both legs) and years of hard drinking had worn down his body. After a strong year in '64 capped by three World Series home runs (his 18 homers in 12 World Series broke Ruth's record), he and the Yankees began a rapid decline. After hitting just .237 in 1968, he quit in disgust at age 37.

Mantle's 536 homers, 1,509 RBI, and leadership on seven World Series champions guaranteed him a Hall of Fame plaque, but his perseverance alone became legendary.

MAJOR LEAGUE TOTALS									
BA	G	AB	R	H	2B	3B	HR	RBI	SB
.298	2,401	8,102	1,677	2,415	344	72	536	1,509	153

CAREER STRIKEOUT LEADERS

1. **Nolan Ryan** 5,714
2. **Randy Johnson** 4,875
3. **Roger Clemens** 4,672
4. **Steve Carlton** 4,136
5. **Bert Blyleven** 3,701
6. **Tom Seaver** 3,640
7. **Don Sutton** 3,574
8. **Gaylord Perry** 3,534
9. **Walter Johnson** 3,509
10. **Justin Verlander** 3,416

Roger Clemens

Not since 1924 had both the American League and National League featured a pitching Triple Crown winner in the same year until 2011 came along. That season, Detroit's Justin Verlander (24–5, 2.40 ERA, 250 Ks) and Los Angeles's Clayton Kershaw (21–5, 2.28, 248) led their respective leagues in the three Triple Crown categories.

1962: Yankees vs. Giants

Ralph Terry *(pictured)*, who had allowed the Bill Mazeroski homer that ended the 1960 Series in such dramatic fashion, redeemed himself in the taut 1962 fall classic. For six games, the New York Yankees and San Francisco Giants jabbed at each other like testy prizefighters, neither able to establish dominance. Nobody on either team homered more than once or scored more than a handful of runs.

By the time Game 7 rolled around, each team's ace starter (Jack Sanford for the Giants, Terry for the Yanks) had won one and lost one game. They faced off against each other, and it wasn't over until Giants slugger Willie McCovey drilled a line drive up the middle with two on and two out in the last of the ninth with the Yanks up 1–0—a line drive that second baseman Bobby Richardson snared to end the game.

Game 1	New York 6 at San Francisco 2	**Game 5**	San Francisco 3 at New York 5
Game 2	New York 0 at San Francisco 2	**Game 6**	New York 2 at San Francisco 5
Game 3	San Francisco 2 at New York 3	**Game 7**	New York 1 at San Francisco 0
Game 4	San Francisco 7 at New York 3		

2016: Cubs vs. Indians

The Chicago Cubs did not expect the task of ending a 108-year World Series title drought—or "curse," some might say—to be easy. And it certainly wasn't. It took one of the most exciting World Series marathons in years, against a Cleveland lineup also intent on ending a lengthy championship hiatus, to give Cubs fans something they'd waited generations to see.

Cleveland took three of the first four games, putting the North Siders's backs to the wall. Having to win three straight games, the Cubs did just that. They squandered a two-run lead in the late innings of Game 7 in Cleveland, but a perfectly timed rain delay allowed them to regroup and win it with a two-run surge in the 10th. Against all odds, the Cubs were "loveable losers" no more.

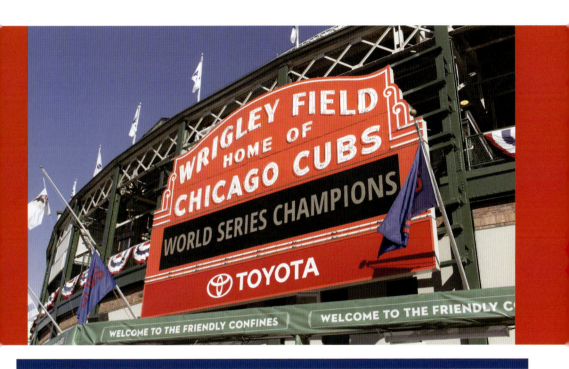

Game 1	Chicago 0 at Cleveland 6	Game 5	Cleveland 2 at Chicago 3
Game 2	Chicago 5 at Cleveland 1	Game 6	Chicago 9 at Cleveland 3
Game 3	Cleveland 1 at Chicago 0	Game 7	Chicago 8 at Cleveland 7 (10)
Game 4	Cleveland 7 at Chicago 2		

MEMORABLE MOMENT

Charismatic slugger Reggie Jackson brought excitement to the Bronx in 1977, but Yankees fans were more interested in a world championship, which they hadn't experienced in 15 years. Jackson took care of that in Game 6 of the World Series against Los Angeles. Incredibly, he belted three home runs on three swings, the last being a 450-foot bomb to right field amid chants of "Reggie! Reggie! Reggie!" The Game 6 dramatics of "Mr. October" clinched the world title.

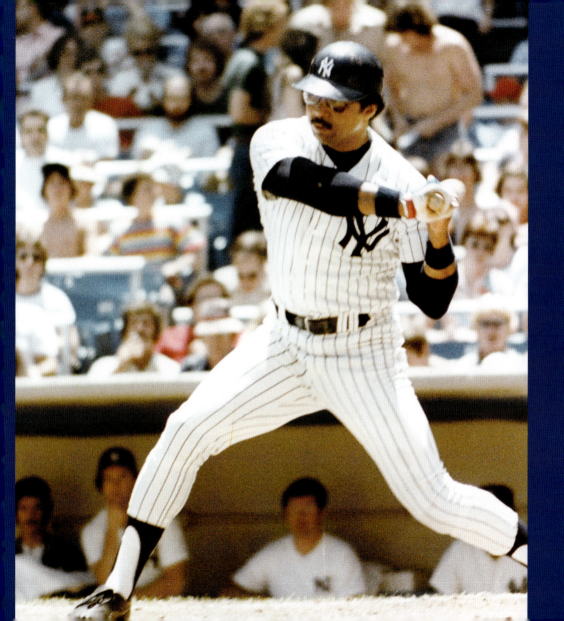

THE DOUBLEDAY MYTH

When a 1907 commission formed by A. G. Spalding set out to prove the true origins of baseball, there was little mention of previous versions of bat-and-ball games amidst patriotic praise for the supposed architect of "America's Game": Major General Abner Doubleday.

The story went that Doubleday, as a Cooperstown, New York, youngster in 1839, had drawn up a diagram of a diamond for a game he called "Town Ball." Conveniently, Doubleday later went on to some tall-tale heroics as the soldier who spotted the first gun fired at Fort Sumter, and he was supposedly at Abraham Lincoln's deathbed when the president leaned over and whispered in Doubleday's ear, "Abner, don't...let... baseball...die."

A great story but merely a myth—especially considering Doubleday was actually at West Point in 1839 and was never known to even follow the game he supposedly invented.

Alexander Joy Cartwright, a New York bank teller and talented draftsman, was the first to suggest teams of nine players, equidistant bases, and three outs per inning. Today, Cartwright's Hall of Fame plaque credits him as "the Father of Modern Base Ball," while Doubleday, the man responsible for the placement of the Hall of Fame in Cooperstown, has himself never been enshrined.

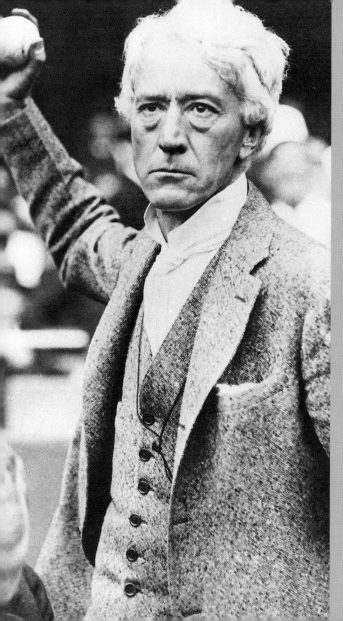

Baseball commissioner Judge Kenesaw Mountain Landis showed no mercy for those Chicago White Sox who accepted money for throwing the 1919 World Series. Landis kicked eight "Black Sox" out of major-league baseball, including some who may have been innocent.

Ken Griffey Jr. was named Player of the Decade for the 1990s by his fellow major-leaguers. A .300 hitter who could fly, Junior also won 10 Gold Glove Awards in the decade while blasting 382 home runs.

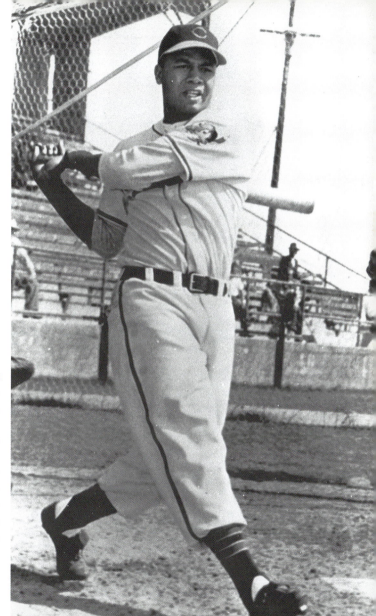

Nearly three months after Jackie Robinson broke baseball's color barrier, Larry Doby became the first African American to play in the American League. In 13 big-league seasons, Doby was a seven-time All-Star who hit at least 25 homers five times and drove in 100-plus runs five times.

TARGET FIELD, MINNEAPOLIS

After almost three decades of playing indoors, the Minnesota Twins were thrilled to step outside in 2010 with the opening of Target Field. Well, at least on most days. It can be a little brisk on an early-season evening, but that's why it was built with the only bonfire in the Majors. Set in the historic warehouse district of Minneapolis, this downtown gem is packed with state-of-the-art features and amenities for its approximately 40,000 patrons. Hungry? Try some home-cooked Minnesota walleye or any number of "state fair foods" on a stick.

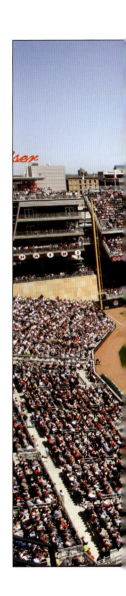

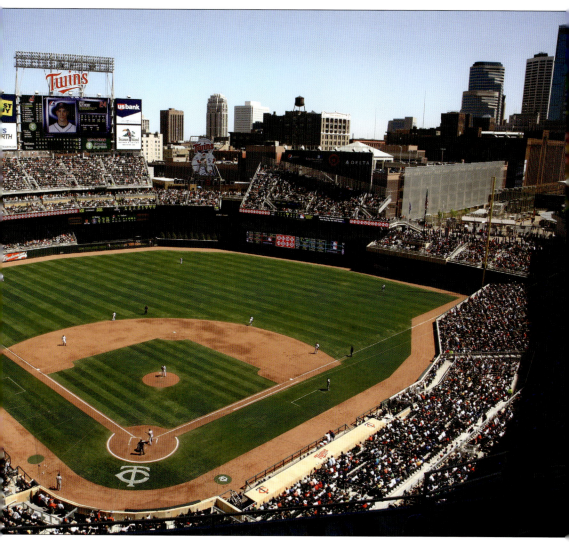

NOTABLE NICKNAMES

Emil "Hill Billy" Bildilli

George "Bingo Binks" Binkowski

Paul "Motormouth" Blair

Dennis "Oil Can" Boyd

Ron "The Penguin" Cey

Ron "Louisiana Lightning" Guidry

Reggie "Mr. October" Jackson - ┐

Slothful Bill Lattimore

Sudden Sam McDowell

Hugh "Losing Pitcher" Mulcahy

John "Blue Moon" Odom

Charlie "The Old Woman in the

Red Cap" Pabor

Lou "The Nervous Greek" Skizas

Frank "Sweet Music" Viola ┐

2019: Nationals vs. Astros

How big was Howie Kendrick's home run off the right field foul pole in Game 7 of the 2019 World Series? Well, it was just the second time in history that a batter hit a go-ahead home run in the seventh inning or later of a winner-take-all World Series game—the first since 1960. MLB.com ranked it among the 10 most important hits in postseason history.

The Astros, playing the deciding game at home, entered the seventh inning up 2–0 and cruising. The Nationals, however, had chased starter Zack Greinke and trimmed the lead to 2–1 when Kendrick stepped up to the plate with the tying run on the base.

Kendrick lofted a Will Harris pitch to the opposite field and fans watched nervously as the ball caromed off the foul pole for a go-ahead home run. His teammates went wild in the dugout and never looked back, wrapping up the first World Series championship in franchise history by a 6–2 score.

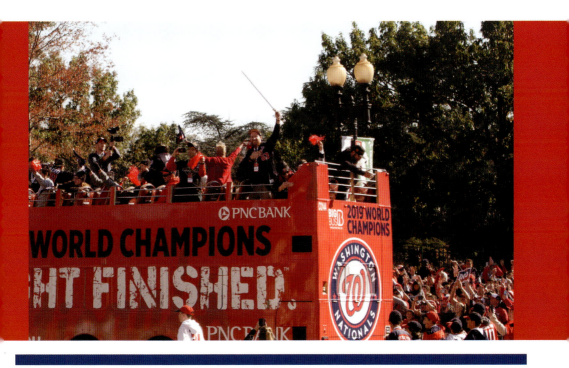

Game 1	Washington 5 at Houston 4		**Game 5**	Houston 7 at Washington 1
Game 2	Washington 12 at Houston 3		**Game 6**	Washington 7 at Houston 2
Game 3	Houston 4 at Washington 1		**Game 7**	Washington 6 at Houston 2
Game 4	Houston 8 at Washington 1			

ENTER "SANDMAN"

When it comes to big-game closers, there was none better than Mariano Rivera. The Panama City native, who pitched all 19 Major League seasons with the Yankees, became known as "Sandman" because his presence in a game meant lights out for the opposition.

Using basically one pitch—the best split-finger fastball anyone had ever seen—Rivera set numerous regular-season and postseason records for closing success. He is the all-time MLB saves leader in both the regular season and playoffs. His 0.70 postseason ERA also set a new record as he led the Yankees to four World Series championships between 1996 and 2000.

"He belongs in a higher league, if there is one," Twins manager Tom Kelly once said of Rivera. "Ban him from baseball. He should be illegal."

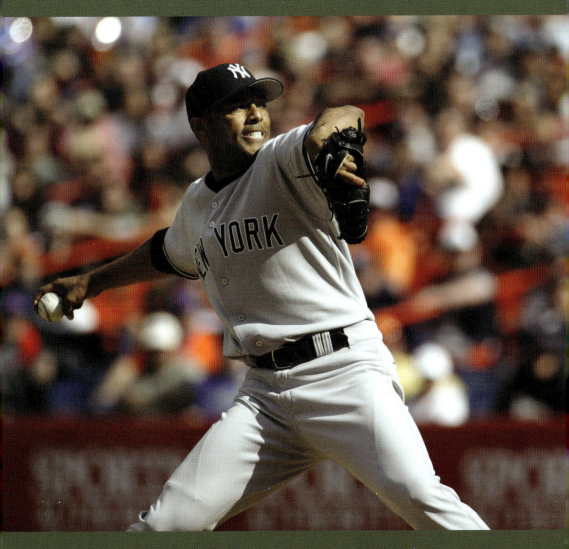

PETCO PARK, SAN DIEGO

The stucco-walled Petco Park opened in 2004 to glowing reviews. Upon entering the ballpark, Padres fans pass by a palm court, jacaranda trees, and water walls. Once inside, they're treated to views of the city skyline and other fascinating sites beyond the outfield fence, including a "beach" and a "park" for fans to enjoy. The four-story Western Metal Supply building, part of the left-field wall, has been transformed into luxury suites, a restaurant, and rooftop seating for 800 lucky fans.

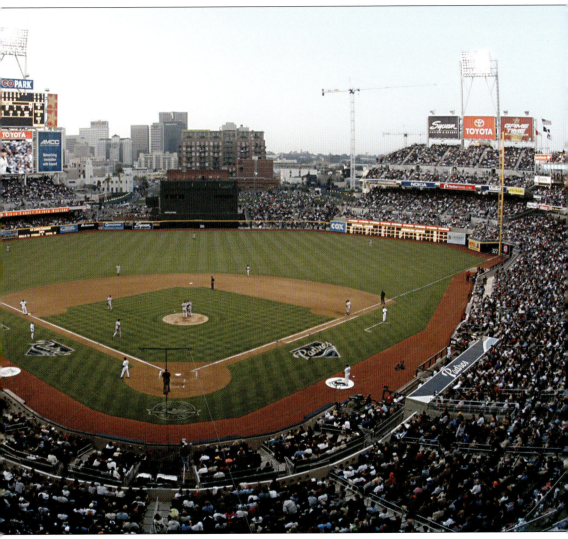

CAREER HOME RUN LEADERS

1. **Barry Bonds** 762
2. **Hank Aaron** 755
3. **Babe Ruth** 714
4. **Albert Pujols** 703
5. **Alex Rodriguez** 696
6. **Willie Mays** 660
7. **Ken Griffey Jr.** 630
8. **Jim Thome** 612
9. **Sammy Sosa** 609
10. **Frank Robinson** 586

Hank Aaron

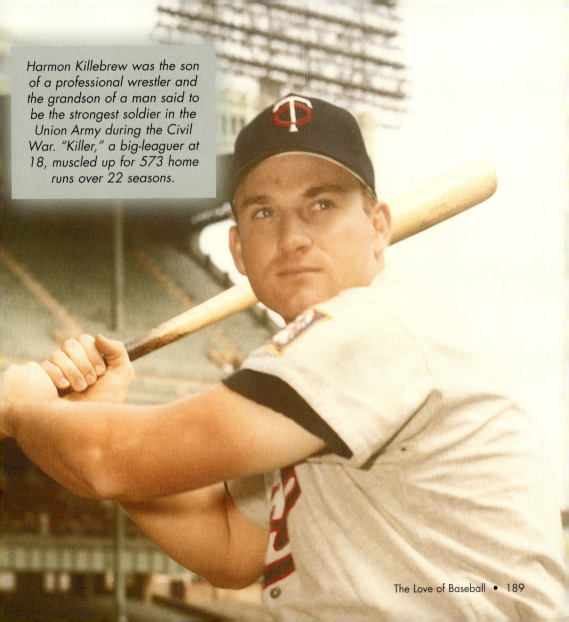

Harmon Killebrew was the son of a professional wrestler and the grandson of a man said to be the strongest soldier in the Union Army during the Civil War. "Killer," a big-leaguer at 18, muscled up for 573 home runs over 22 seasons.

AFTER FURTHER REVIEW

The heckling of umpires is a long-standing baseball tradition. Many fans got their wish beginning in 2008, when baseball took a cue from its football counterparts and adopted instant replay reviews for certain situations.

The current replay rule has been in effect since 2014. It allows each manager one "challenge" per game, with additional challenges granted if the previous challenge is successful. Beginning in the seventh inning, the umpire crew chief is also allowed to initiate reviews.

"You missed the call!" can still be heard from the cheap seats. Now, however, something can be done about it.

2020: Dodgers vs. Rays

There was nothing normal about the 2020 MLB season, thanks to the COVID-19 pandemic. Most of the season was cancelled, protocols and illness impacted play, and stadiums turned to cardboard cutouts instead of fans in the seats. So, it was no surprise that by the time October rolled around, the World Series would be one of a kind. Los Angeles and Tampa Bay played all six games in Arlington, Texas, where seating capacity was limited to 11,500— 25 percent of its normal capacity.

The teams split the first four games before the Dodgers rode their strong pitching—featuring an all-homegrown starting rotation—to wins in Games 5 and 6, ending their 32-year World Series title drought. Because the post-season field had been expanded to 16 teams, the Dodgers also set a record for playoff victories with 13. Dodgers shortstop Corey Seager was named MVP of both the AL Championship Series and World Series. He batted .328 in the 18 postseason games.

Fans watched the World Series from their cars during a drive-in live broadcast at the Dodger Stadium in Los Angeles.

Game 1	Tampa Bay 3 at Los Angeles 8	**Game 5**	Los Angeles 4 at Tampa Bay 2
Game 2	Tampa Bay 6 at Los Angeles 4	**Game 6**	Tampa Bay 1 at Los Angeles 3
Game 3	Los Angeles 6 at Tampa Bay 2		
Game 4	Los Angeles 7 at Tampa Bay 8		

PETE ROSE

Baseball's all-time hit leader (4,256), Rose surpassed Ty Cobb's major-league record in 1985—a record that stood for 57 years.

"Charlie Hustle" ranks first on all-time lists in games played and at-bats, second in doubles, and sixth in runs scored.

He compiled the longest hitting streak in modern National League history (44 games) in 1978 and topped .300 15 times throughout his career.

The 17-time All-Star and 1973 league MVP was considered the heart and soul of Cincinnati's Big Red Machine.

Despite his having bested Cobb's career hit mark, Rose's spot in the Hall of Fame remains empty due to his implication in a gambling scandal.

MAJOR LEAGUE TOTALS									
BA	G	AB	R	H	2B	3B	HR	RBI	SB
.303	3,562	14,053	2,165	4,256	746	135	160	1,314	198

"I'd walk through hell
in a gasoline suit to
play baseball."
—Pete Rose

MEMORABLE MOMENT

Game 6 of the 1975 World Series, Cincinnati at Boston, has been called the greatest game ever played. After Boston's Bernie Carbo tied it at 6–6 with a homer in the eighth, outfielders George Foster (Reds) and Dwight Evans (Red Sox) each prevented scores with spectacular double plays. At 12:34 a.m., in the 12th inning, Boston's Carlton Fisk pulled a high fly ball down the left-field line, then frantically tried to "wave" it fair. Almost unbelievably, the ball hit the foul pole and bounced fair, winning the game. Elation rocked through Red Sox land; this was as good as it got. The joy in Boston lasted just one day, however, as the Reds prevailed in Game 7.

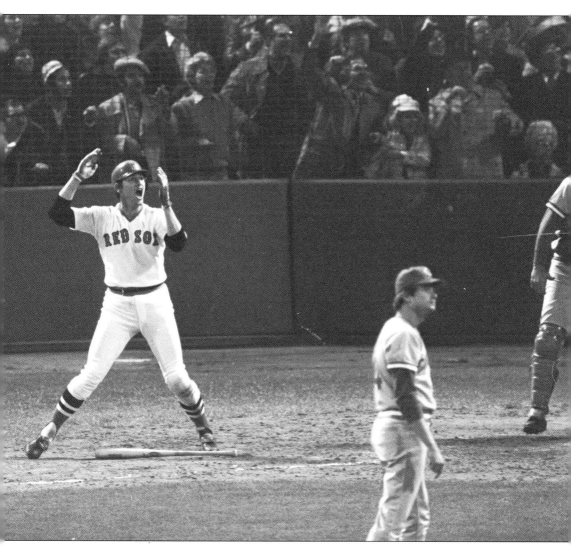

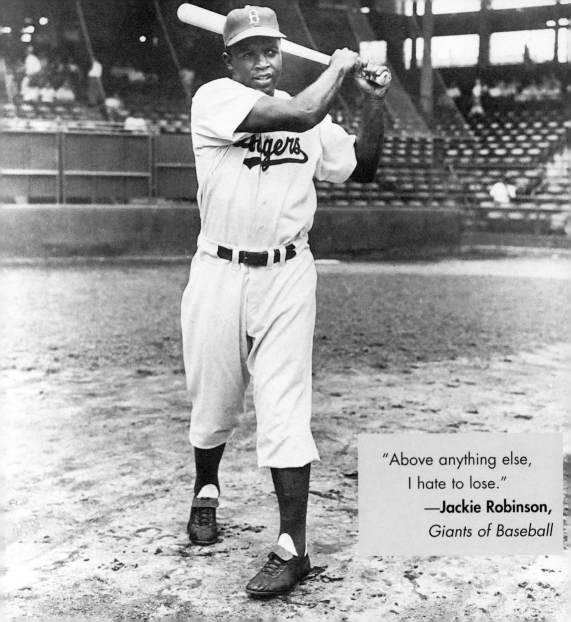

"Above anything else,
I hate to lose."
—**Jackie Robinson,**
Giants of Baseball

"If I had one wish in the world today, it would be that Jackie Robinson could be here to see this happen."
—**Frank Robinson** on being made the first black manager in major-league history

1972: Athletics vs. Reds

It was the new wave versus the old guard: the long-haired, mustachioed Oakland A's against the clean-cropped, all-American Cincinnati Reds. Dick Williams managed Charlie Finley's wild brigade; Cincy manager Sparky Anderson headed up the Big Red Machine.

By the time they were finished, every game but one had been decided by one run. Reds superstar Johnny Bench, in the midst of an intentional walk on a 3–2 pitch, watched strike three zip past him. Oakland's Gene Tenace, with four homers, established himself as one of the World Series's unexpected heroes. A's closer Rollie Fingers preserved a 3–2 win in Game 7, and the fuzzy misfits of Oakland won their first of three consecutive world championships.

Game 1	Oakland 3 at Cincinnati 2
Game 2	Oakland 2 at Cincinnati 1
Game 3	Cincinnati 1 at Oakland 0
Game 4	Cincinnati 2 at Oakland 3

Game 5	Cincinnati 5 at Oakland 4
Game 6	Oakland 1 at Cincinnati 8
Game 7	Oakland 3 at Cincinnati 2

NOLAN RYAN

Nolan Ryan was perhaps baseball's most beloved figure from the mid-1970s into the early '90s. His record 5,714 whiffs seems to be a mark that will stand indefinitely.

The "Ryan Express" captured 11 strikeout crowns with California, Houston, and Texas. His 383 punch-outs with the Angels in 1973 remain a major-league record.

Thanks to 20 seasons of double-digit victories throughout his 27-year major-league career, Nolan is tied for 15th on the all-time list with 324.

Ryan authored a record seven no-hitters (three more than anyone else), the last of which came at age 44.

MAJOR LEAGUE TOTALS									
W	L	ERA	G	CG	IP	H	ER	BB	SO
324	292	3.19	807	222	5,386	3,923	1,911	2,795	5,714

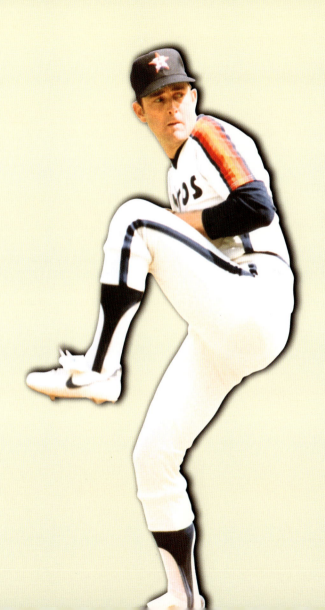

Ryan so overpowered Detroit during his no-hitter on July 15, 1973, that desperate slugger Norm Cash stepped to the plate carrying a piano leg.

PACKED HALL

It was a banner year for the Baseball Hall of Fame in 2014. First, President Barack Obama paid a visit in May, delivering a speech promoting tourism in the States. It marked the first time a sitting president ever visited the Hall.

Then, later in the summer, the "Big Six" were inducted before the third-largest crowd in the history of the Cooperstown event. The inductees were 300-game winners Greg Maddux and Tom Glavine; slugger Frank Thomas; and managers Joe Torre, Bobby Cox, and Tony La Russa.

An estimated 48,000 fans soaked up the electric atmosphere. Among them were 44 of the 66 living Hall of Famers.

A TOUCH OF CLASS

After Kris Bryant hit his third home run of the game on June 27, 2016, the huge throng of Cubs fans cheered for him to come out of the dugout for a curtain call. Bryant certainly deserved one. This was the day he became the first Major Leaguer in history to sock three home runs and two doubles in one game. Just one problem, though—the game was in Cincinnati. Not wanting to show up the home team, Bryant stayed in the dugout.

JOE DIMAGGIO

He was the most regal of performers during his career with the New York Yankees, and the quiet, somewhat mysterious way he carried himself in later years only added to the legend of Joe DiMaggio.

Upon first coming to the Yankees in 1936, DiMaggio was no early candidate for nobility. This poor son of an Italian fisherman had what reporters called "squirrel teeth" and the naïveté to believe that a quote was some kind of soft drink. After hitting .323 with 44 doubles, 15 triples, 29 home runs, and 125 RBI in his rookie season, he outdid even the great Lou Gehrig his second year, leading the league with 46 homers and 151 runs while batting .346.

Joe was a flawless ballplayer. A right-handed batter who almost always made contact—never striking out more than 39 times in a season. He was hampered by the 457-foot "Death Valley" in left-center field of Yankee Stadium but still managed to hit .315 there over his career. As a center fielder, he was fast and graceful but never flashy, making great plays look easy. Though quiet, he was a leader in the Yankee clubhouse.

After winning batting titles in 1939 (when his .381 mark earned him the MVP Award) and '40 (.352), DiMaggio captured the attention of the entire country in '41. From May 15 to July 17, Joltin' Joe racked up a record 56-game hitting streak, during which he hit .408 with 15 homers. If it hadn't been for two great stops by Cleveland's Ken Keltner, the streak would have stayed alive for who knows how long.

The next day, Joe began another hitting streak, this one continuing for 17 games. He was the subject of songs, prompted contests and endless media coverage, and beat out Ted Williams (a .406 batter on the season) for his second MVP trophy.

World War II intervened in 1943, and the 31-year-old DiMaggio came back three years later slightly below his previous form. His average and power numbers were down. He still won a third MVP Award with subpar .315–20–97 totals in 1947. Despite lagging his own records, DiMaggio still had a flair for the dramatic. After missing the first 65 games of the 1949 season with a heel injury, he returned to the lineup in Boston and hit four homers in three games—sparking the Yankees to the seventh of the nine world championships they would win in his 13-year career.

While his final statistics do not approach the all-time greats, when injuries and military service are factored in, Joe's average season translates into 34 homers, 143 RBI, and a .579 slugging percentage—numbers worthy of his 1969 selection by Major League Baseball as its "greatest living player."

"Sometimes a fellow gets a little tired of writing about DiMaggio; a fellow thinks 'There must be another ballplayer worth mentioning.' But there isn't, really, not worth mentioning in the same breath as DiMaggio."
—Columnist **Red Smith**

MAJOR LEAGUE TOTALS									
BA	G	AB	R	H	2B	3B	HR	RBI	SB
.325	1,736	6,821	1,390	2,214	389	131	361	1,537	30

To prepare for his part as Grover Cleveland Alexander in the
1952 film The Winning Team, *future president Ronald Reagan* (right)
worked with Cleveland's ace Bob Lemon.

RIGHT PLAYER, RIGHT TIME

How's this for a stat? From 2015 to 2016, 100% of the teams with Ben Zobrist in their lineups won the World Series. "BenZo," one of the game's most versatile players, won a title with the Royals in 2015 before signing with the Chicago Cubs ahead of the 2016 season. He then earned World Series MVP honors after leading the Cubs to their first championship in 108 years.

MEMORABLE MOMENT

Game 7 of the 1960 World Series at Pittsburgh turned into a delirious rollercoaster ride. The Pirates went up 9–7 in the eighth inning thanks to a bad-hop grounder off Tony Kubek's throat and a Hal Smith three-run homer. But New York tied it up in the ninth in amazing fashion, forcing extra innings. Pittsburgh second baseman Bill Mazeroski, leading off in the bottom of the ninth, smashed a climactic game-winning homer that brought the players and Pittsburgh fans to their feet in celebration. Jubilant fans poured onto the field to celebrate the first World Series-ending homer in major-league history.

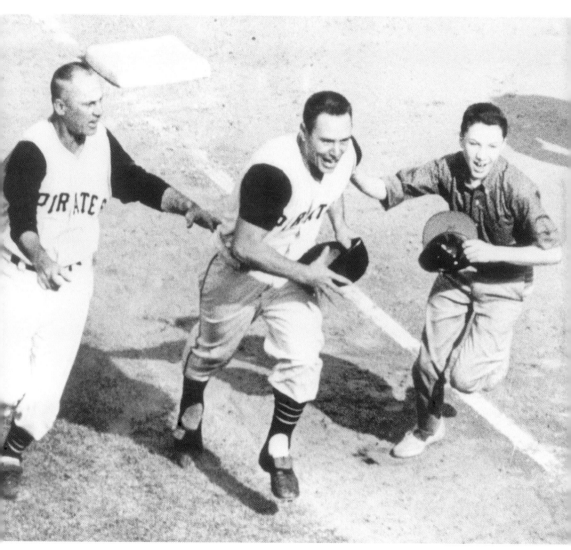

NOTABLE NICKNAMES

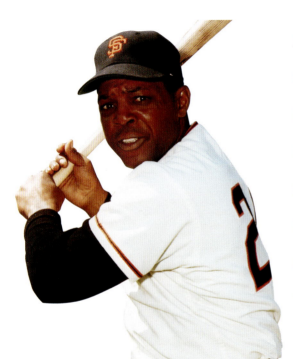

Jittery Joe Berry

Don "The Weasel" Bessent

Ewell "The Whip" Blackwell - - - - - - - - - - -

Downtown Ollie Brown

Pearce "What's the Use" Chiles

Nick "Old Tomato Face" Cullop

Willie "The Say Hey Kid" Mays

Fred "Crime Dog" McGriff

Julio "Whiplash" Navarro

Babe "The Sultan of Swat" Ruth - - - - - - - - -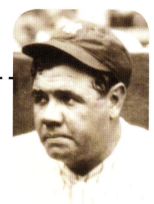

George "Twinkletoes" Selkirk

Moe "The Rabbi of Swat" Solomon

Bill "Mumbles" Tremel

Walt "No-Neck" Williams - - - - - - - -

Jimmy "The Toy Cannon" Wynn

SINGLE-SEASON HOME RUN LEADERS

1. **Barry Bonds** 73 2001
2. **Mark McGwire** 70 1998
3. **Sammy Sosa** 66 1998
4. **Mark McGwire** 65 1999
5. **Sammy Sosa** 64 2001
6. **Sammy Sosa** 63 1999
7. **Aaron Judge** 62 2022
8. **Roger Marris** 61 1961
9. **Babe Ruth** 60 1927
10. **Babe Ruth** 59 1921
 Giancarlo Stanton 59 2017

Barry Bonds

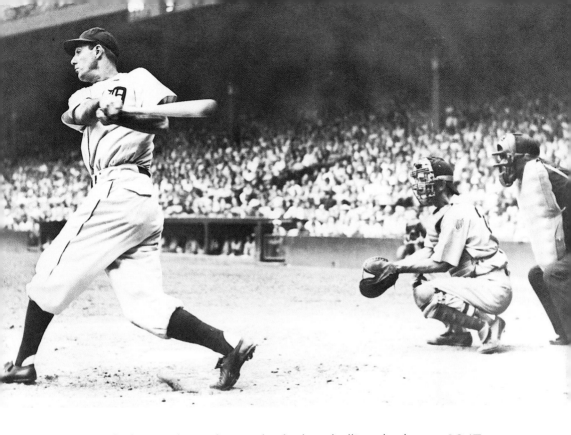

Long before Jackie Robinson broke baseball's color line in 1947, another talented young player survived a slew of racial epithets en route to a Hall of Fame career. Hank Greenberg, the greatest Jewish slugger in the game's history, still stands as baseball's sixth-best slugger with a .605 lifetime mark, and his career average of .92 RBI per game matches Lou Gehrig's 20th-century record.

1991: Twins vs. Braves

Minnesota and Atlanta were not even supposed to be in the World Series in 1991, as both had finished last in their respective divisions just the season before. Though a classic, this series was not noted for dramatic turnarounds or big comebacks. The two clubs just played each other about as deadly even as possible, and they did it for seven games.

There were weird plays, marathon games, unexpected heroes, creative baserunning, home-plate collisions, and dramatic homers. Kirby Puckett's stellar catch and 11th-inning, game-winning homer for Minnesota in Game 6 to stave off Series defeat was one of the greatest clutch performances of all time. In Game 7, Twins ace Jack Morris pitched a 10-inning shutout, and Minnesota won in the bottom of the 10th on a Gene Larkin single.

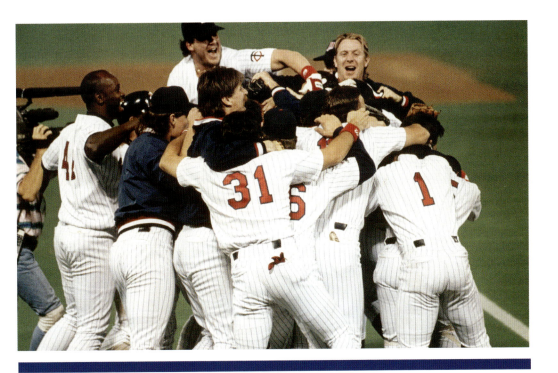

Game 1	Atlanta 2 at Minnesota 5	Game 5	Minnesota 5 at Atlanta 14
Game 2	Atlanta 2 at Minnesota 3	Game 6	Atlanta 3 at Minnesota 4 (11)
Game 3	Minnesota 4 at Atlanta 5 (12)	Game 7	Atlanta 0 at Minnesota 1 (10)
Game 4	Minnesota 2 at Atlanta 3		

MEMORABLE MOMENT

After winning the 1992 World Series, the Toronto Blue Jays found themselves in a war with Philadelphia in the '93 fall classic. With their team down 6–5 in the bottom of the ninth in Game 6, Jays fans prayed for a rally to avoid a seventh game. With two on and one out, slugger Joe Carter worked the count to 2–2 on Mitch "Wild Thing" Williams—then crushed the next pitch over the left-field fence. After dancing around the bases, Carter was hoisted on the shoulders of his elated mates.

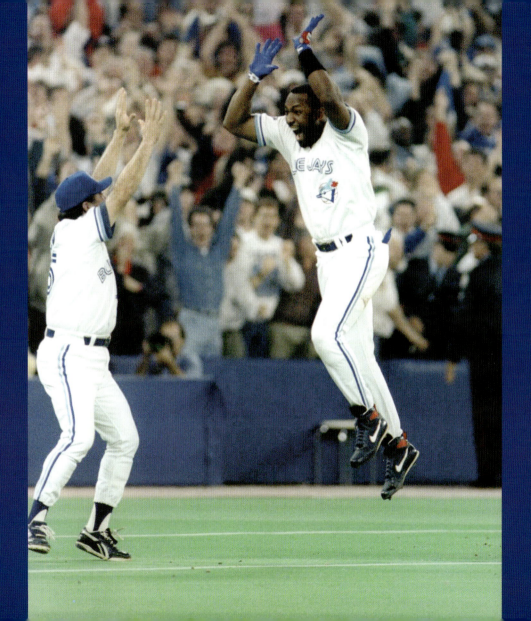

Unconventional A's owner Charlie Finley was a powerful, penurious, and polarizing force during the '70s. On Opening Days, he forced his players to ride onto the field on mules such as "Charlie O," the team mascot.

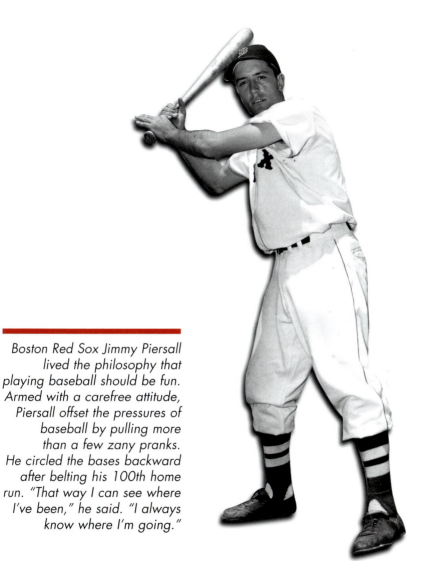

Boston Red Sox Jimmy Piersall lived the philosophy that playing baseball should be fun. Armed with a carefree attitude, Piersall offset the pressures of baseball by pulling more than a few zany pranks. He circled the bases backward after belting his 100th home run. "That way I can see where I've been," he said. "I always know where I'm going."

STAN MUSIAL

A minor-league pitcher in 1940, Musial hurt his throwing arm diving to make a catch. Forced to the outfield when the injury failed to heal, he still made the majors the very next summer—and retired 22 years later as a .331 lifetime hitter with 475 homers, 1,951 RBI, and 3,630 hits.

Throughout the baseball world, Stan the Man was known as "an outstanding artist in his profession…a gentleman in every sense of the word."

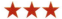

Musial won seven NL batting titles and topped .300 17 times in his 22-year career. He was named the league's MVP three times (1943, '46, and '48) and was a 20-time All-Star.

"I believe the joy of getting paid as a man to play a boy's game kept me going longer than many other players."

—Stan Musial

MAJOR LEAGUE TOTALS										
BA	G	AB	R	H	2B	3B	HR	RBI	SB	
.303	3,562	14,053	2,165	4,256	746	135	160	1,314	198	

PNC PARK, PITTSBURGH

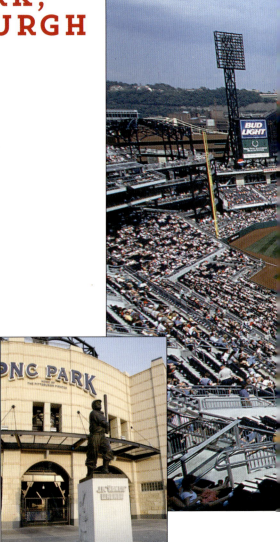

With the emergence of many ballpark gems in recent years, ball fans and architects have struggled to decide which is best. ESPN and the website Ballparks of Baseball are among those who have picked Pittsburgh's PNC Park. The Roberto Clemente Bridge leads fans to an intimate ballpark with a panoramic view of the city's skyline. Features include statues of Pirates legends, baseball's most detailed scoreboard, and Manny Sanguillen's barbecue sandwiches.

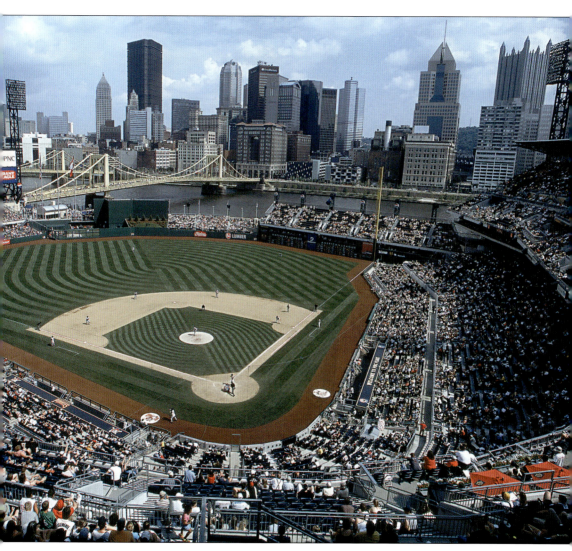

HANK AARON

A glance at the lifetime stats of great players quickly shows the seasons in which they fell below what was expected or when they failed to deliver. Henry "Hank" Aaron's stats, however, were consistently at the highest level. He slugged 20 home runs or more for 20 seasons in a row. The great Babe Ruth did it only 16 times. He scored 100 runs in 13 consecutive seasons. And he tallied more than 100 RBI over and over again.

Aaron himself outlined the reason for the shape of his career: "Patience. It's something you pick up pretty naturally when you grow up black in Alabama. When you wait all your life for respect and equality and a seat in the front of the bus, it's nothing to wait a little longer for the slider inside."

At age 35, Aaron was considering retirement when historian Lee Allen sat him down for a chat. Allen pointed out that Aaron was only a few home runs behind Mel Ott for the all-time National League record, and that Aaron stood a good chance to reach the 3,000-hit plateau as well as set the all-time record for at-bats. Aaron perked up.

He realized he could quickly change the nature of his relatively silent career, and then he could use his reputation to make a difference in the situation of blacks in sports and throughout American life, as he stated in his autobiography, *I Had a Hammer.* Of course, Allen never mentioned Ruth's record of 714 lifetime homers. That record was untouchable, or so everyone at the time agreed.

So Aaron kicked things up a notch, increasing his home run total from 29

in 1968 to 44 in '69. Then he hit 38, then 47 (the most he ever knocked in one season—and he was 37 years old!), followed by 34. The race to catch Ruth really began—a race against age, time, and bigotry. He withstood the pressure of a deluge of hate mail containing racial slurs and death threats, as well as a massive media blitz, and began a sensational finishing kick. In 1973, at age 39, Aaron slugged 40 homers—one in every 9.8 at-bats. He began the 1974 season just one behind the Babe.

Hate mail or not, Aaron was on a mission. He tied Ruth in his first plate appearance of the season. Two games later he walked in his first at-bat, then came around to score a run that broke Willie Mays's lifetime National League record. No one noticed. The next time he came to the plate, he used his magical wrists to loft an Al Downing pitch over the left-field fence in Atlanta. As he circled the bases, announcer Milo Hamilton shouted, "There's a new home run champion of all time, and it's Henry Aaron!"

With day-in, day-out consistent excellence over 20 years, Aaron had pushed aside the unbreakable record. He finished his career two years later with 755 homers (a mark for the next guy to shoot for), 2,297 RBI (also a record), 3,771 hits (third all-time), and 2,174 runs—third all-time, and the same number accumulated by a guy named Ruth.

> "Trying to throw a fastball by Henry Aaron is like trying to sneak a sunrise past a rooster."
> —Opposing pitcher **Curt Simmons**

MAJOR LEAGUE TOTALS									
BA	G	AB	R	H	2B	3B	HR	RBI	SB
.305	3,298	12,364	2,174	3,771	624	98	755	2,297	240

FLEET FEET

★★★★
BASEBALL'S FASTEST BASERUNNERS

Cool Papa Bell
George Case
Vince Coleman
Kenny Lofton
Mickey Mantle
Deion Sanders
Ichiro Suzuki
Evar Swanson
Herb Washington
Willie Wilson

Satchel Paige said that Cool Papa Bell was so fast, he could turn off the light switch and be in bed before the room got dark. Another story goes that Bell swatted a ball up the middle but was out when it hit him before he could slide into second. The truth is he was simply amazing. Starring in the 1920s and '30s, Bell routinely scored from second on fly-outs or infield groundouts, and he claimed he once stole 175 bases in a 200-game season.

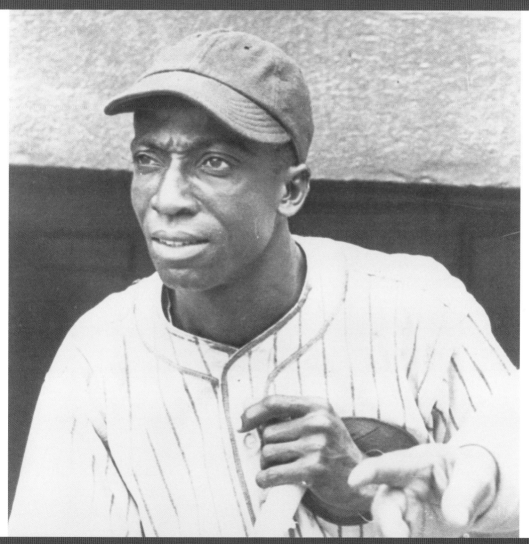

CAREER RBI LEADERS

1. **Hank Aaron** 2,297
2. **Albert Pujols** 2,218
3. **Babe Ruth** 2,213
4. **Alex Rodriguez** 2,086
5. **Barry Bonds** 1,996
6. **Lou Gehrig** 1,995
7. **Stan Musial** 1,951
8. **Ty Cobb** 1,944
9. **Jimmie Foxx** 1,922
10. **Eddie Murray** 1,917

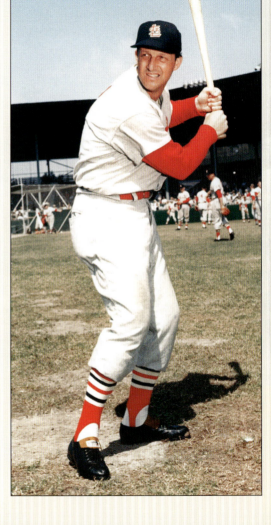

Stan Musial

An estimated 200,000 San Franciscans welcomed the arrival of the Giants from New York on April 14, 1958. The next day, sluggers Willie Mays *(left)* and Hank Sauer *(right)* helped their club beat the Dodgers, 8–0, in the first game ever played on the West Coast.

MEMORABLE MOMENT

Mets slugger Pete Alonso had been struggling at the plate, but he sure picked an opportune time to turn it around. With two men on base and his team trailing 2–0 in the ninth inning of Wild Card series Game 3 in Milwaukee, Pete worked the count to 3–1 before drilling a three-run homer over the right field wall. In sending the Mets to the 2024 NLDS, he became the first player in MLB postseason history to hit a go-ahead homer with his team trailing in the ninth inning or later of a winner-take-all game.

FAMILY TIES

Baseball is the ultimate family sport, from dads coaching their children's Little League games to lazy afternoons keeping score in the bleachers to the heart-tugging final scene in *Field of Dreams:* "Hey Dad, want to have a catch?"

For some, the bond takes place at the highest level. Father-son duos have been prominent in the Majors since the game grew old enough for multiple generations. In fact, it's old enough now that there are no less than five three-generation families that have reached the "bigs."

One of them—the Boones—is a three-generation family of MLB All-Stars. Ray Boone was an All-Star in the 1950s and his son, Bob, made the Midsummer Classic in the '70s and '80s. Bob's sons, Bret and Aaron, are more recent All-Stars. The Bells (Gus, Buddy, David, and Mike) were the second three-generation family to reach the Majors, followed by the Hairstons (Sammy, Jerry, Jerry Jr., and Scott) and the Colemans (Joe, Joe Jr., and Casey).

Daughters have been involved, too. Kim Schofield Werth, a track star who made the 1976 U.S. Olympic Trials, has a father (Ducky Schofield) and a brother (Dick Schofield) who both earned World Series rings. Her son Jayson Werth went

Left to right: *Jesús, Matty, and Felipe Alou*

on to a 15-season career in the MLB. Because Kim married Dennis Werth—Jayson's stepfather—who also played in the Majors, another multigenerational Major League family was born.

Two of the most famous and productive father-son duos are Griffey and Bonds. Late in the 1990 season, Ken Griffey Sr. and Ken Griffey Jr. became the first father-son duo to play together. They started next to each other as the left and center fielders for the Mariners and also batted in succession—second and third in the order. They once homered in the same game.

However, no father-son duo has been more productive than the Bondses. Bobby's 332 homers combined with Barry's 762 add up to a grand total of 1,094 round-trippers.

In the brotherly love category, Hank and Tommie Aaron hold the combined home run record. Their total of 768 included just 13 by Tommie, a regular only as a rookie (1962). Joe Niekro hit his only major-league homer against brother Phil, beating him in a 1976 game. Together, the Niekros won more games (539) than any other pair of pitching brothers.

The three Alou brothers—Felipe, Matty, and Jesús—batted in the same inning when the San Francisco Giants played the Mets at Shea Stadium in 1963. It was the only time in history three brothers batted for the same team in the same inning.

MIKE SCHMIDT

One of baseball's greatest power sources and a spectacular defenseman, Schmidt was named the starting third baseman on major-league baseball's All-Century Team.

The reliable fence buster, who led the National League in homers a record eight times, holds the major-league record for home runs by a third sacker in a career (548).

Over his career, Schmidt earned three NL MVP Awards and 10 Gold Gloves—an NL record for a third baseman—and powered Philadelphia to the 1980 world title—their first title in 97 years.

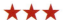

Schmidt twice hit four consecutive home runs: once within the same game and once spanning two games.

MAJOR LEAGUE TOTALS									
BA	G	AB	R	H	2B	3B	HR	RBI	SB
.267	2,404	8,352	1,506	2,234	408	59	548	1,595	174

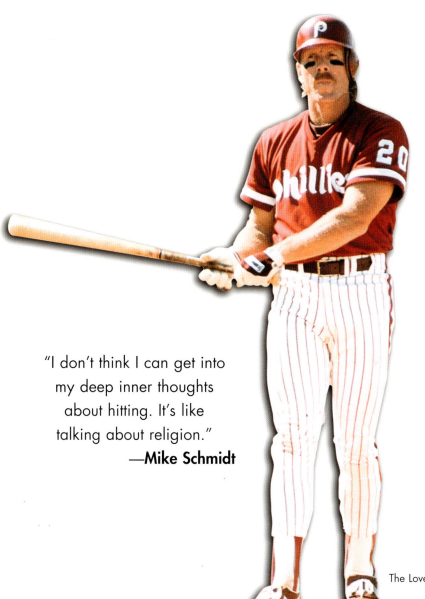

"I don't think I can get into my deep inner thoughts about hitting. It's like talking about religion."
—**Mike Schmidt**

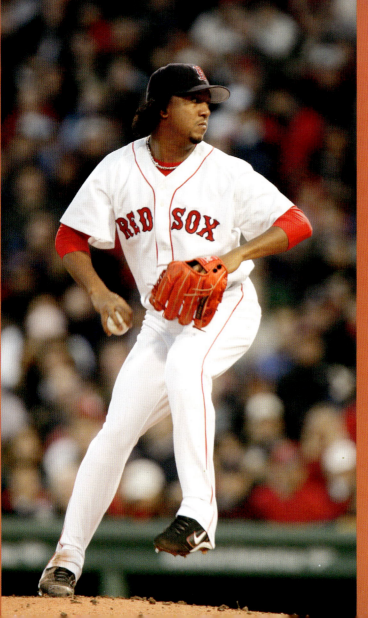

As a child in the Dominican Republic, Pedro Martínez sometimes played ball with the head of his sister's doll because he couldn't afford baseballs. Martínez had a career record of 219–100 and boasted the fourth-best winning percentage in major-league history when he retired in 2009.

TAKE YOUR BASE

Beginning in 2017, pitchers no longer have to throw four balls on purpose to intentionally walk a batter. Instead, a team's manager can now simply point an opposing batter to first base. The change was designed to help take "dead time" out of the game.

2001: Diamondbacks vs. Yankees

After mourning the September 11 tragedy for weeks, New Yorkers sought diversion in the World Series, as the Yankees aimed for their fourth straight world title. Fans sat back and watched a surreal fall classic that featured three of the most dramatic Series games ever played.

Down two games to one to Arizona, New York's Tino Martinez tied Game 4 on Halloween night with a two-out home run in the ninth. Yankee Derek Jeter clubbed a walk-off homer after midnight, earning the nickname "Mr. November." Incredibly, New York's Scott Brosius tied Game 5 with a two-out, ninth-inning homer, and the Yanks won in 12. But in Game 7, Arizona scored two in the bottom of the ninth to win 3–2, as Luis Gonzalez ended it with a bases-loaded single.

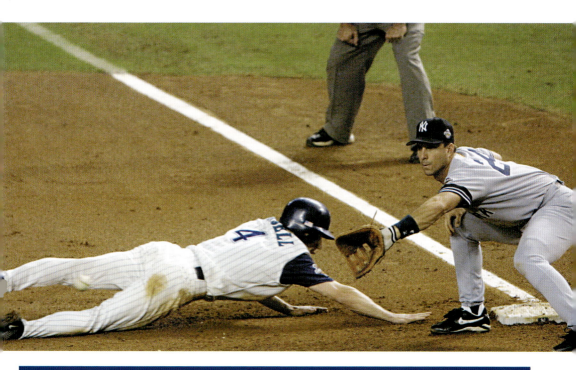

Game 1	New York 1 at Arizona 9	Game 5	Arizona 2 at New York 3 (12)
Game 2	New York 0 at Arizona 4	Game 6	New York 2 at Arizona 15
Game 3	Arizona 1 at New York 2	Game 7	New York 2 at Arizona 3
Game 4	Arizona 3 at New York 4 (10)		

LOU GEHRIG

Lou Gehrig's record of 2,130 consecutive games no longer stands, but what Gehrig accomplished in the seasons comprising his string remains a remarkable achievement. Only his own Yankee teammate, Babe Ruth, can claim a more prodigious level of sustained offensive excellence.

Gehrig was a wise and modest man who drew far more solace from family than nightclubs. A native New Yorker and left-handed slugger at Columbia University, the sturdy six-footer joined the Yankees at age 20 in 1923 and saw limited duty behind star first baseman Wally Pipp for two seasons. The first game of Gehrig's streak came on May 31, 1925, when he entered the game as a pinch hitter. When he started the next day after Pipp complained of a headache, nobody thought much of it. In the end, Gehrig played the final 126 games of the season, finishing at .295 with 20 homers, and Pipp was out of a job.

Cleanup hitter on the Yankee pennant-winners of 1926, Lou paced the American League with 20 triples while adding 47 doubles, 16 homers, and 112 RBI. He also hit .348 in a World Series loss to St. Louis, but Ruth (who preceded him in the New York batting order) remained the main man with 47 homers and four more in the Series. "The Iron Horse" lessened the gap in '27, running neck and neck with Babe much of the season before finishing with 47 dingers. Although Ruth set the world afire by smashing a record 60 for the world

champs, Gehrig won Most Valuable Player honors with astounding totals of 218 hits, a .373 average, 175 RBI, 52 doubles, 18 triples, and a .765 slugging percentage.

Lou upped his average to .374 in '28, leading the league with 47 doubles and 142 RBI. Similar stats followed each of the next nine years. Over 11 full seasons from 1927 to '37, Lou averaged .350 with 39 homers and 153 RBI (including an AL-record 184 in '31) while playing on five pennant-winners and four world champions. His numbers fell off to .295–29–114 when the Yanks took their third straight Series in '38, and some speculated that the streak was getting to him. In reality,

> "He was a symbol of indestructibility— a Gibraltar in cleats."
> —Sportswriter **Jim Murray**

the problem was a rare and incurable disease called amyotrophic lateral sclerosis—now known as Lou Gehrig's disease—that was slowly eating away at his body.

The suddenly sluggish and feeble-footed star took himself out of the lineup on May 2, 1939, and upon learning his fate shortly thereafter never played again. On July 4, 1939, as the Yankees saluted Gehrig in a sold-out tribute ceremony at Yankee Stadium, he told the hushed crowd that he had "an awful lot to live for." But less than two years later, he was dead at age 37—his 493 homers, 1,995 RBI, and .340 average a lasting testament to his greatness.

MAJOR LEAGUE TOTALS									
BA	G	AB	R	H	2B	3B	HR	RBI	SB
.340	2,164	8,001	1,888	2,721	534	163	493	1,995	102

MEMORABLE MOMENT

After a players' strike ruined the 1994 season, Baltimore's Cal Ripken lured fans back to the game, winning them over on September 6, 1995. With President Bill Clinton and Vice President Al Gore in attendance, the classy Oriole played in his 2,131st consecutive game, eclipsing Lou Gehrig's "unbreakable" record. Ripken drove fans into a frenzy with a fourth-inning homer, then ran a "thank you" lap when the game became official after five innings.

THE HOMER IN
THE GLOAMIN'

As darkness descended upon the friendly confines of Wrigley Field on September 28, 1938, hope for the beloved Cubs was still flickering in the twilight.

The Cubbies and Pirates were separated in the standings by half a game. The score was tied 5–5 in the bottom of the ninth inning with two outs. Had Pittsburgh managed to procure the third out, it was likely that the umpires would have called the game due to darkness, as it was already difficult for the batters to see the ball.

But as the last rays of sun disappeared and twilight wrapped itself around the park, Chicago's catcher-manager Gabby Hartnett launched a two-strike pitch into the left-field seats, securing a dramatic 6–5 win. The ecstatic crowd spilled onto the field and, along with the rest of the Cubs, joined Hartnett

in a jubilant dash around the bases. The Cubs, who had trailed the Pirates by as many as nine games in August, had finally climbed into first place as the sun was setting over Wrigleyville, and Hartnett's long ball was thereby christened the Homer in the Gloamin'.

Inability to control his fearsome fastball kept Johnny Vander Meer out of the Hall of Fame. But when he was on, he was almost unhittable. In June 1938, Vander Meer, just 23 years old, became the only man in baseball history to pitch consecutive no-hit games.

MEMORABLE MOMENT

Never before had a team clawed their way back from a 3–0 deficit to win a playoff series. But the Boston Red Sox did it in wild, exhilarating, unbelievable fashion in October of 2004—and against whom? Their bitter rivals, the New York Yankees. With their backs to the wall, the Red Sox reeled off a three-game win streak to even the series and then finished off the Yanks in decisive fashion. Star Johnny Damon swatted two home runs (one of them a grand slam) and drove in six runs in the seventh game, helping the team to a 10–3 victory. The Sox extended the streak to eight straight games, sweeping the St. Louis Cardinals to claim their first world title in 86 years. The curse Babe Ruth had supposedly laid on them had finally been reversed.

MEMORABLE MOMENT

In 1998 St. Louis's Mark McGwire and the Cubs's Sammy Sosa thrilled the nation with their assault on baseball's season home run record. With its spirit of competitive camaraderie, the race was more than just a pursuit of numbers; it captured imaginations nationwide. Big Mac surpassed Roger Maris's major-league mark with his 62nd homer on September 8. Slammin' Sammy continued the drama by tying McGwire at 66. But Mac distanced himself on the final weekend, finishing with the then-unfathomable total of 70.

"I can't believe I did it," McGwire said. "Can you?"

Casey Stengel bids farewell to Yankee Stadium for the 1957 season after his club dropped the World Series to the Braves. He returned to the Series the next year, in another seven-game thriller, to win a rematch with the boys from Milwaukee.

"Every great batter works on the theory that the pitcher is more afraid of him than he is of the pitcher."

—Ty Cobb,
The Tiger Wore Spikes

"It could be....It might be....It is! A home run!"
—Broadcaster **Harry Caray's** signature call